POMPOM POKEMON

Sachiko Susa

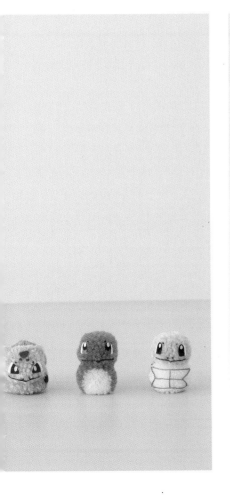

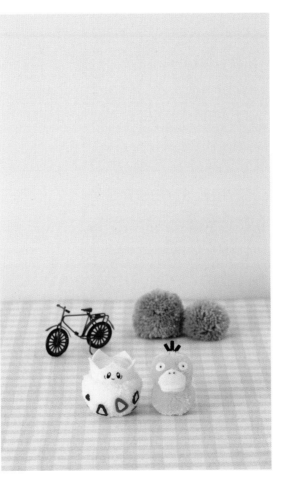

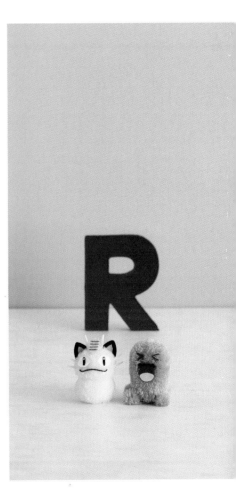

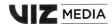
VIZ MEDIA

Let's Make Pompom Pokémon

Pompom Pokémon Ideas

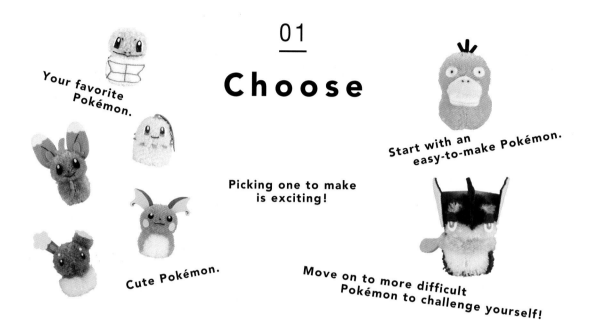

01
Choose

Your favorite Pokémon.

Picking one to make is exciting!

Cute Pokémon.

Start with an easy-to-make Pokémon.

Move on to more difficult Pokémon to challenge yourself!

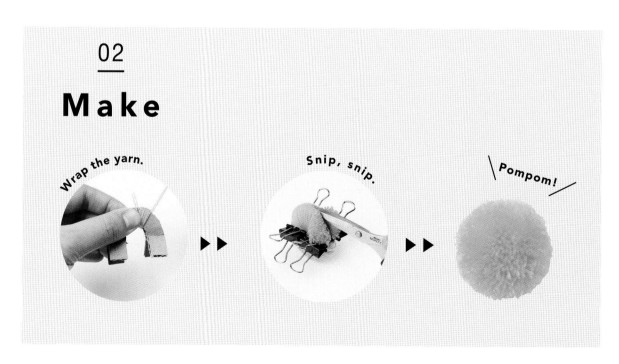

02
Make

Wrap the yarn.

Snip, snip.

\ Pompom! /

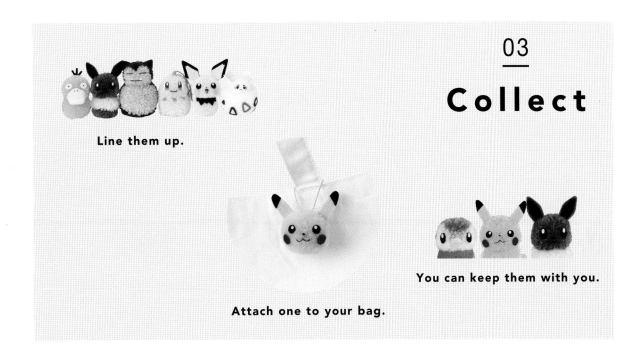

Line them up.

03
Collect

Attach one to your bag.

You can keep them with you.

04
Gift

If it's a gift...

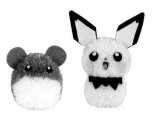

Whom shall I give one to?

Someone dear to my heart.

...you'll want to
make it supercute.

Contents

Pompom Pokémon

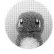
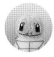

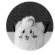
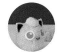
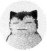

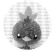
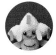
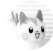

How to Make Pompom Pokémon

Pokémon the Series: The Beginning
Pokémon the Series: Gold and Silver
1997–2002

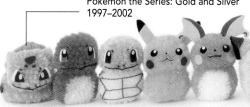
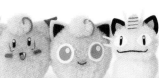
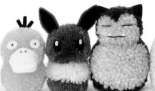
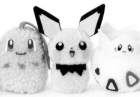

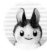

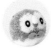

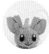

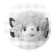
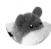

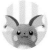
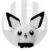

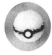

Pokémon the Series: Ruby and Sapphire 2002–2006

Pokémon the Series: Black and White 2010–2013

Pokémon the Series: Sun & Moon 2016–

Pokémon the Series: Diamond and Pearl 2006–2010

Pokémon the Series: XY 2013–2016

Pokémon the Series: The Beginning

1997–2002

At ten years old, Ash sets off on a journey with his partner, Pikachu. Together with Misty and Brock, they travel through the Kanto region, the Orange Islands and the Johto region. It all started from there.

SCENE 1 Ash's Pikachu

Upon leaving Pallet Town, Ash's first Pokémon is given to him by Professor Oak.

Ash and Pikachu become best friends and partners on their journey together.

In the background there's ketchup, Pikachu's favorite.♡

01

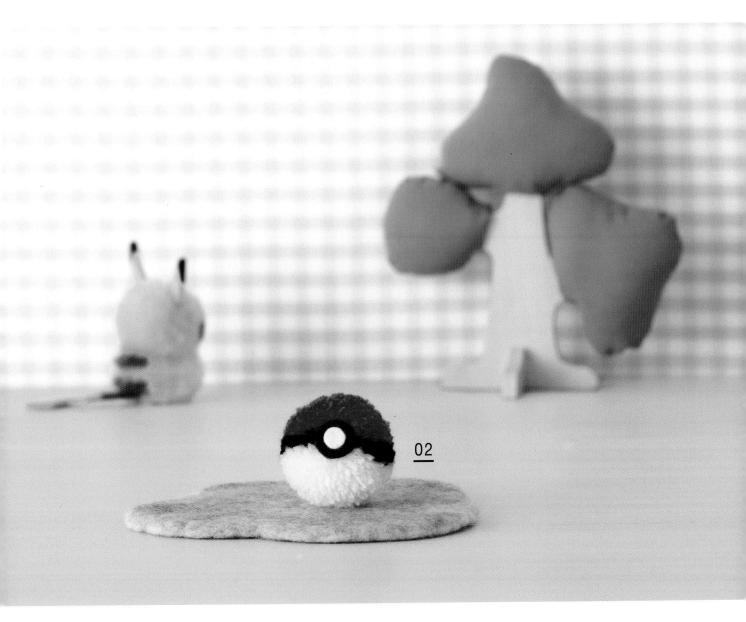

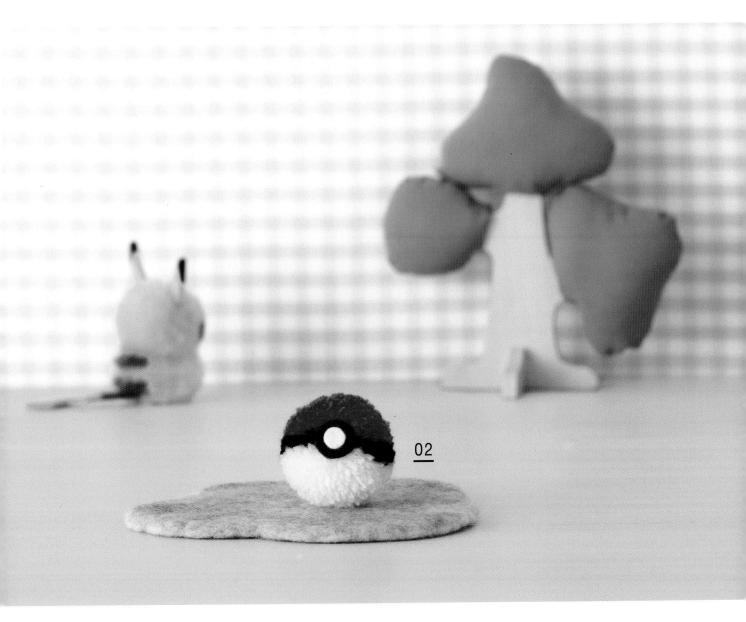

01 Pikachu

Ash's buddy. The instructions for making Pikachu come with photos, so this is a good pompom Pokémon to make first.

Pattern on p. 40

02 Poké Ball

A ball to catch Pokémon. There are pattern tips for how to make your lines neat and straight.

Pattern on p. 46

² Kanto Region: First Friends of the Journey

These friends travel through the Kanto region with Ash.

They are the first-partner Pokémon given out by Professor Oak.

On the morning of his departure, Ash oversleeps and shows up late to pick his first Pokémon, so he is stuck with Pikachu.

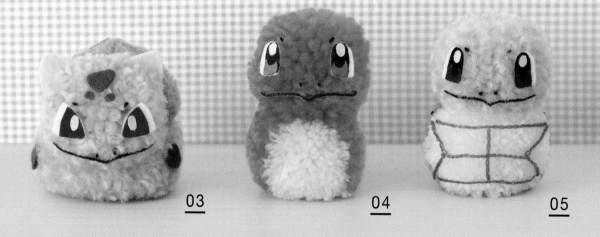

03 04 05

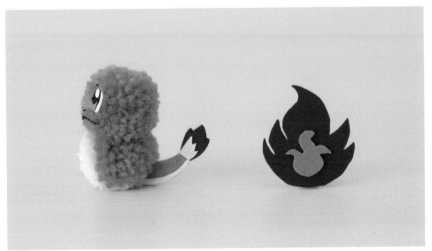

03 Bulbasaur

Ash's partner. It fights bravely to protect weaker Pokémon. You need to make only two pompoms, but trimming can be a bit difficult.

Pattern on p. 50

04 Charmander

It is weak after being abandoned by a Trainer. Ash saves it, and it becomes his partner. Charmander's flame, an indicator of his remaining life force, can be made by gluing pieces of felt.

Pattern on p. 51

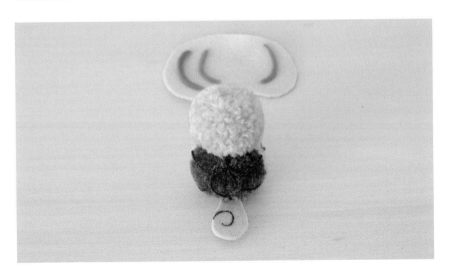

05 Squirtle

The former leader of the mischievous "Squirtle Squad." With its signature Water Gun move, it's also a firefighter in the town. The designs on its stomach and back are made with yarn.

Pattern on p. 52

SCENE 3 Misty's Pokémon

Here are Pokémon that have traveled with Misty.

In the back you can see Misty's red bicycle behind them...!

This bicycle is the reason Misty joins Ash on his journey.

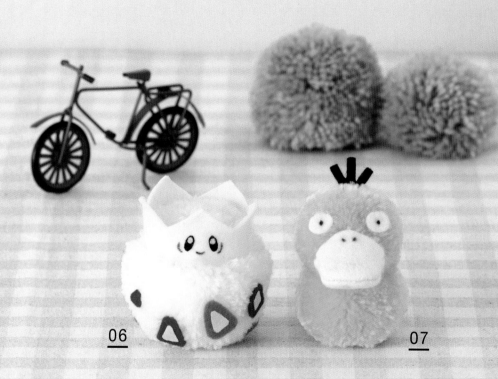

06

07

06 Togepi

Misty's partner. It regards Misty as a parent and is always in Misty's arms. Make sure you double-check where the designs on the stomach go.

Pattern on p. 53

07 Psyduck

It is accidentally caught in Misty's Poké Ball and becomes Misty's partner. The beak is sewn.

Pattern on p. 54

1999

×

Pokémon: The First Movie

Ash receives an invitation and arrives at a castle.
What is waiting for him there is Mewtwo, a clone of Pokémon Mew. Mewtwo plots
revenge against humanity. Mew vs. Mewtwo. Which one will be victorious?

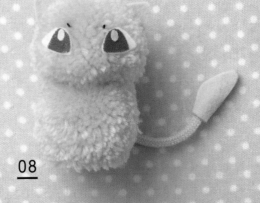

<u>08</u>

<u>08</u> Mew

It has the DNA of every single
Pokémon contained within its body
and can make itself invisible at will.
So even if you make a Mew pompom,
perhaps it will disappear too...?
Pattern on p. 55

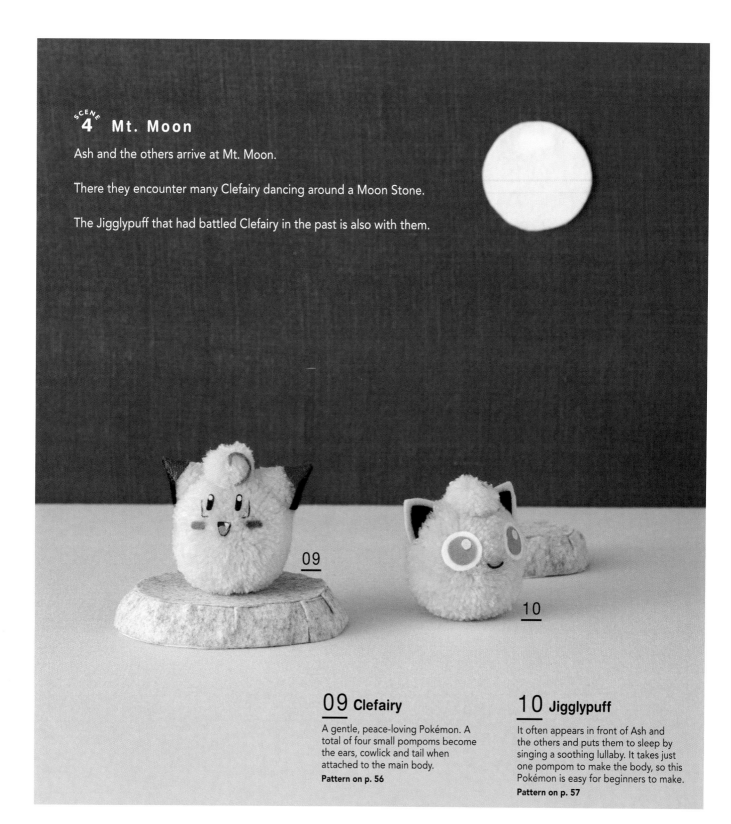

$\overset{\text{SCENE}}{4}$ Mt. Moon

Ash and the others arrive at Mt. Moon.

There they encounter many Clefairy dancing around a Moon Stone.

The Jigglypuff that had battled Clefairy in the past is also with them.

09

10

09 Clefairy

A gentle, peace-loving Pokémon. A total of four small pompoms become the ears, cowlick and tail when attached to the main body.
Pattern on p. 56

10 Jigglypuff

It often appears in front of Ash and the others and puts them to sleep by singing a soothing lullaby. It takes just one pompom to make the body, so this Pokémon is easy for beginners to make.
Pattern on p. 57

^{SCENE} 5 Ash's Snorlax

It's either always eating or sleeping.

Today's no different as it munches away on fruit.

There are times it can't fight in a battle because it won't wake up.

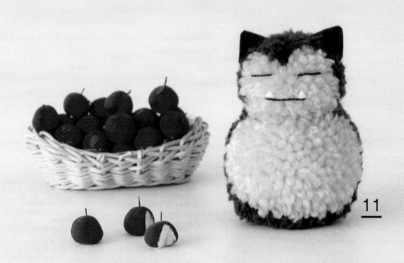

11 Snorlax

Ash's partner. Because it eats so much, its tummy is a size larger.
Pattern on p. 58

Team Rocket

A villainous team that aims to rule the world.

Team members Jessie, James and Meowth try to steal other people's Pokémon, starting with Ash's Pikachu.

It'd be great if you could make these and give them some love—just kidding!

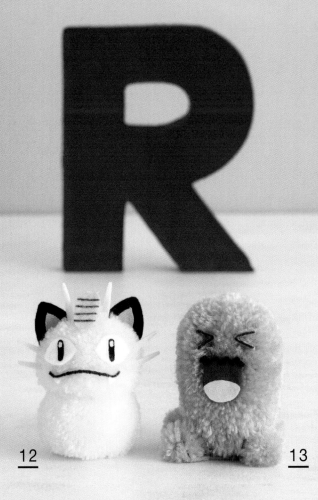

12 13

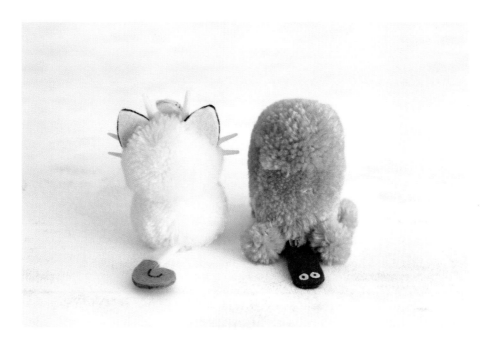

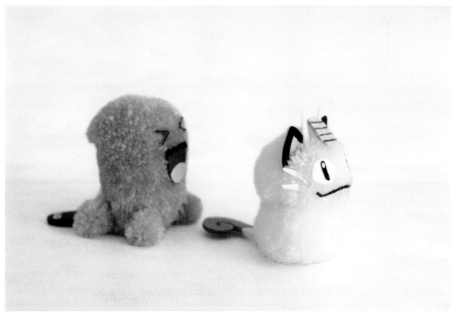

12 Meowth

A member of Team Rocket. After
undergoing intensive training, it learns
to speak the human language. Take
special care when making its Charm.
Pattern on p. 59

13 Wobbuffet

Jessie's Pokémon. It frequently
emerges from its Poké Ball to shout
out its name. Use four small pompoms
to make its legs.
Pattern on p. 60

Pokémon the Series: Ruby and Sapphire

2002–2006

After his journey through the Johto region, Ash arrives in the Hoenn region. A new adventure begins with Brock, May, and Max, May's little brother.

SCENE 7 May's Pokémon

May's goal is to become a top Pokémon Coordinator. These are her partners.

She has entered Pokémon Contests and received numerous ribbons.

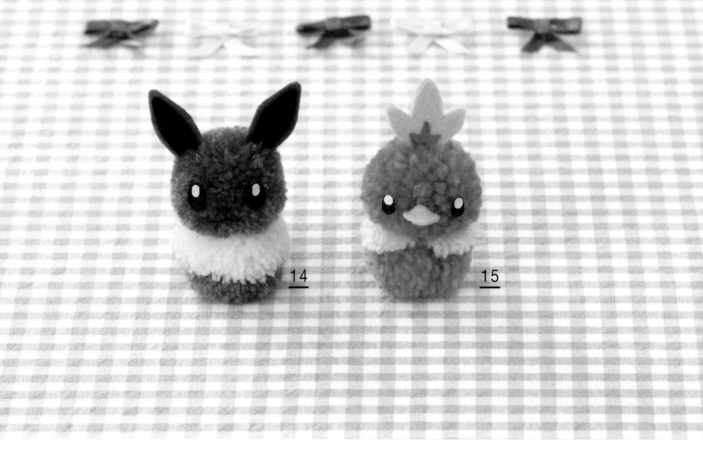

14 Eevee

May receives from a daycare worker an Egg that hatches into an Eevee. For the body, trim the yarn to different lengths.

Pattern on p. 61

15 Torchic

May's first partner, which she receives from Professor Birch. Use a thicker yarn to make it.

Pattern on p. 62

2004
×
Pokémon: Jirachi Wishmaker

Once every thousand years, the Millennium Comet appears in the skies for seven nights. Ash and his friends arrive at a traveling fair where they will have a clear view of the comet. At the fair, they meet a popular magician, Butler, who has a crystallized cocoon with Jirachi sleeping in it. Jirachi awakens, and a seven-day adventure with Jirachi begins.

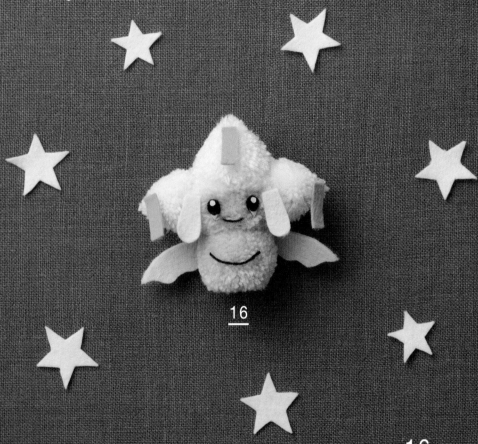

16

16 Jirachi

Legend states that Jirachi will grant any wish that is written on the notes attached to its head when it awakens from its thousand-year slumber. If you make a pompom Jirachi, maybe your wishes will come true too?

Pattern on p. 63

Pokémon the Series: Diamond and Pearl

2006–2010

Ash has come to the Sinnoh region to win the Sinnoh League. He has traveled across the region with Dawn and Brock.

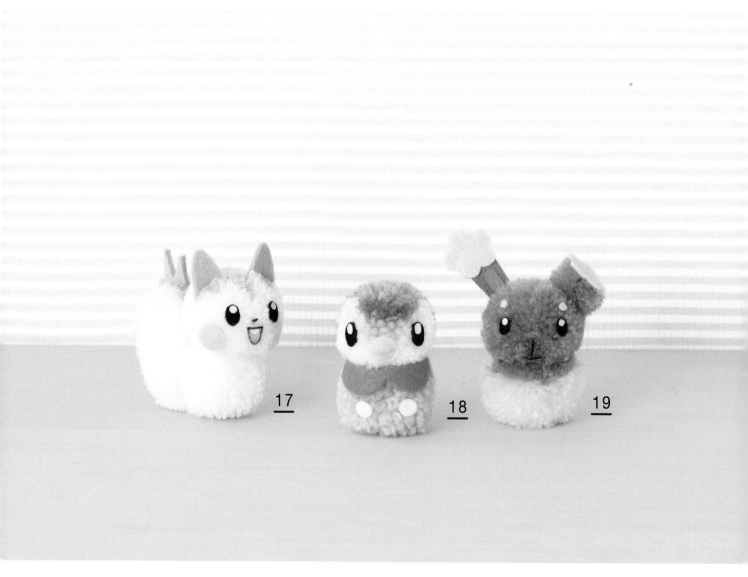

17 Pachirisu

With its cute looks and actions, it's love at first sight for Dawn as she captures Pachirisu. Its large curly tail is its distinctive feature.

Pattern on p. 64

18 Piplup

Dawn's partner. Piplup has a strong sense of self-pride and is also a bit of a klutz. It sometimes falls down, so be sure you carefully trim under its tummy.

Pattern on p. 48

19 Buneary

The first Pokémon Dawn captures. Make a small pompom for its left ear.

Pattern on p. 65

Pokémon the Series: Black and White

2010–2013

Ash travels to the Unova region with his mom, Delia. There he meets Pokémon he's never seen before. He then travels through the region with Iris and Cilan as he prepares for the Unova League.

^{SCENE} 8 Unova

Ash has arrived at the eastern part of Unova.

There he sees Dawn, whom he traveled with in the Sinnoh region.

Dawn's partners, Piplup, Pachirisu and Buneary, are with her too.

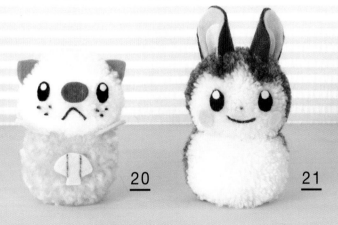

20 21

20 Oshawott

It admires Ash and decides to follow him wherever he goes. Make sure the whiskers are attached symmetrically.
Pattern on p. 66

21 Emolga

Iris's partner. A bit precocious, it drives other Pokémon crazy. Its ears can be made by bending the felt pieces until they are curved.
Pattern on p. 67

Pokémon the Series: XY
2013–2016

With Ash's journey in Unova coming to an end, he heads to the Kalos region. He is off on a new adventure with Serena and siblings Clemont and Bonnie.

SCENE 9 Saying Farewell to Dedenne and Greninja

The last scene in the Kalos region. While saying their goodbyes, Dedenne becomes upset and runs off, but in the end it is able to see off Ash and Pikachu with a smile.

Greninja bids farewell to Ash so that it can stay behind to protect the peace in the Kalos region.

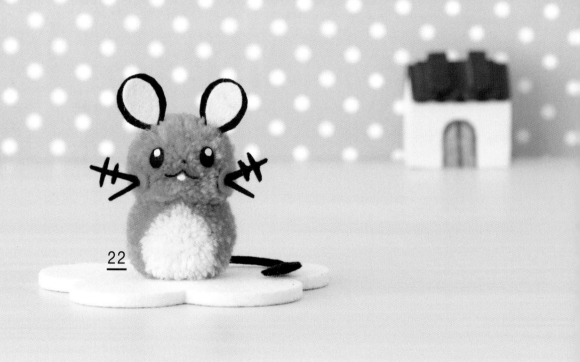

22 Dedenne

Although it is Clemont's partner, Bonnie takes care of it. It loves hanging out in Bonnie's yellow bag. Make a cute Dedenne and carry it with you.
Pattern on p. 68

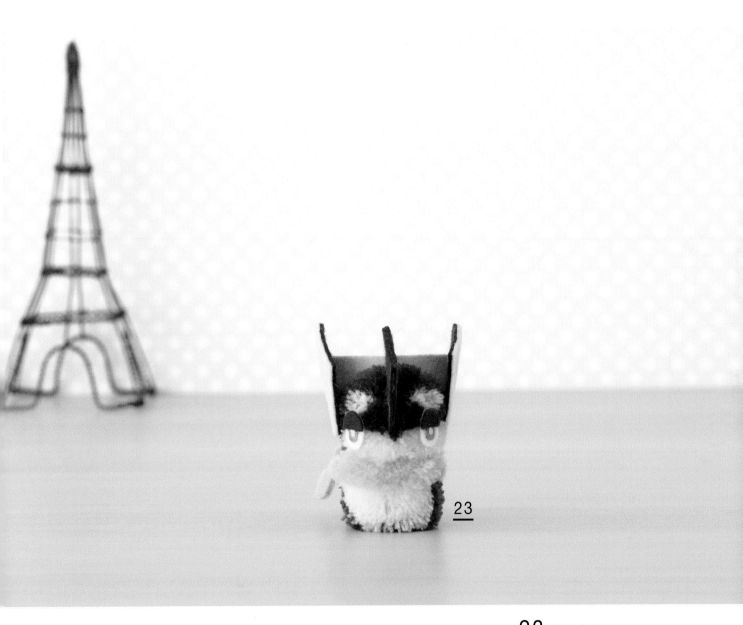

23 Greninja

Caught by Ash, it is the final evolved form of Froakie. It is kind and warmhearted with a strong sense of justice. When making the parts on its head, keep them straight so it'll look strong and cool.

Pattern on p. 69

Pokémon the Series: Sun & Moon

2016–

Ash arrives in the Alola region on vacation and ends up enrolling in Pokémon School. He learns about Pokémon and plays with them. He's in the midst of an awesome adventure!

SCENE 10 — Friends of Ash's Journey in the Alola Region

These are the friends Ash meets in the Alola region.

What kinds of adventure await them?

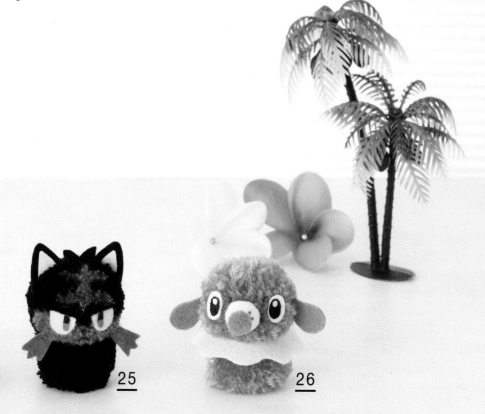

24

25

26

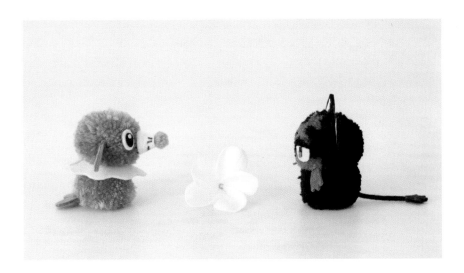

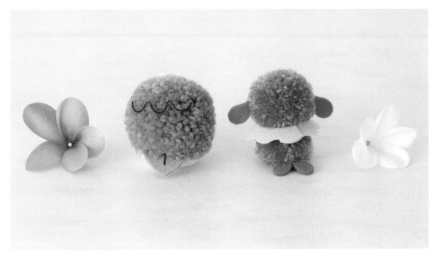

24 Rowlet

Ash's partner. It may be quick to fall asleep, but it proves itself when friends are in trouble. To make it you need just one large pompom.

Pattern on p. 70

25 Litten

It meets Ash near Pokémon School. It lights the fur it collects while grooming to make fireballs that it uses during battles. Don't make pompom Litten into a fireball now!

Pattern on p. 71

26 Popplio

It can make a water balloon with its nose. A tiny pompom is used to make its special nose.

Pattern on p. 72

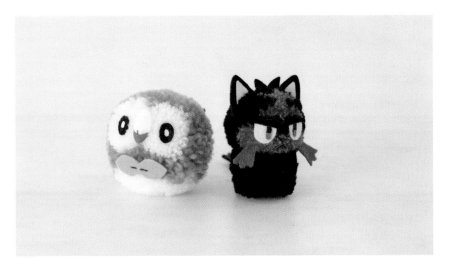

Pokémon Type

In the following pages, we will introduce Pokémon according to type. There are some Pokémon we haven't talked about yet, so be sure to check them out!

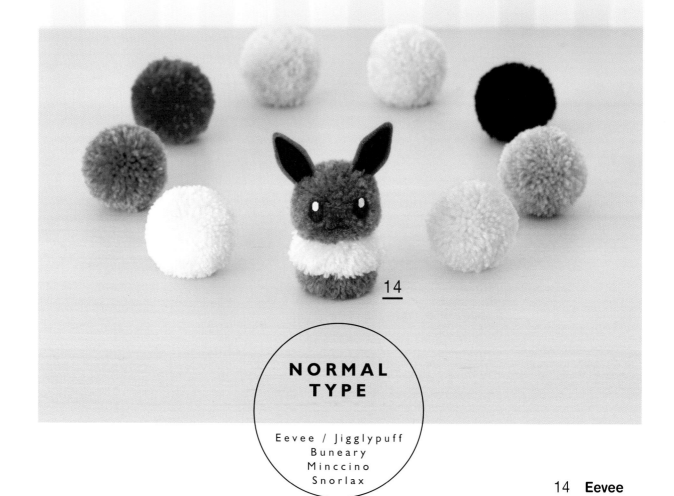

14

NORMAL TYPE

Eevee / Jigglypuff
Buneary
Minccino
Snorlax

14 **Eevee**
→ p. 16
Pattern on p. 61

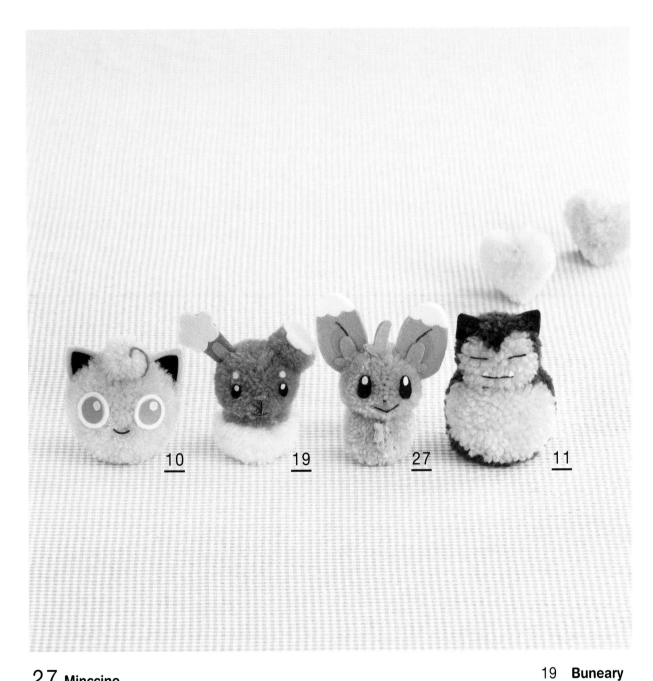

27 Minccino

It loves to clean and uses its tail as a broom to sweep the dust out of its den. Make sure its big ears are symmetrical before attaching them.

Pattern on p. 73

19 Buneary

→ p. 18

Pattern on p. 65

10 Jigglypuff

→ p. 12

Pattern on p. 57

11 Snorlax

→ p. 13

Pattern on p. 58

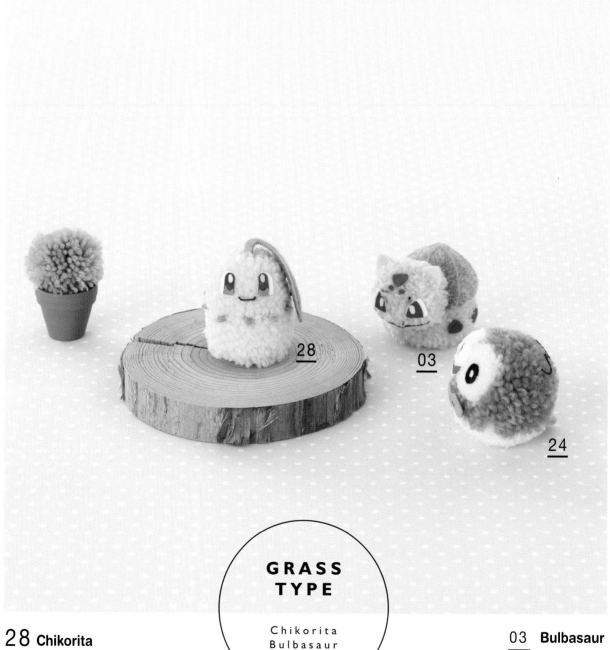

GRASS TYPE

Chikorita
Bulbasaur
Rowlet
Shaymin

28 Chikorita

It loves to soak up sunrays. A sweet aroma gently wafts from the leaf on its head. When attaching the felt pieces around the neck, make sure you evenly space them out.

Pattern on p. 74

03 Bulbasaur

→ p. 8

Pattern on p. 50

24 Rowlet

→ p. 22

Pattern on p. 70

2009
×
Pokémon the Movie: Giratina & the Sky Warrior

Shaymin, the Gratitude Pokémon who was lost, appears in front of Ash.
To carry flower seeds to a faraway place, Shaymin goes with Ash and his friends to the Gracidea
flower garden. That's when Shaymin, Ash and his friends are suddenly sucked into a mirror...

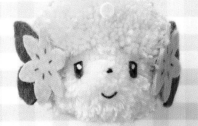

<u>29</u>

<u>29</u> Shaymin

It is said that when the Gracidea flower is in bloom, Shaymin migrate to deliver messages of gratitude. The key is to neatly trim the pompom in the shape of Shaymin.

Pattern on p. 75

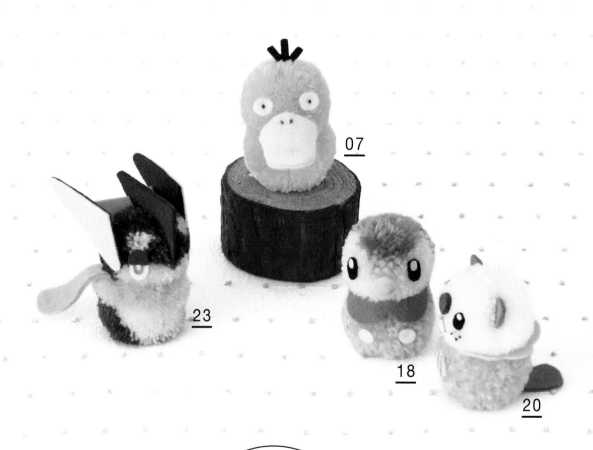

07

23

18

20

WATER TYPE

Greninja / Psyduck
Piplup / Oshawott
Marill / Popplio
Squirtle

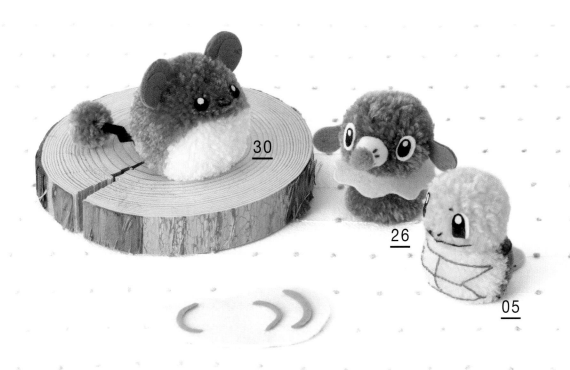

30

26

05

30 Marill

The tip of its tail is filled with oil, which helps it float. Use a small pompom to make the tail.

Pattern on p. 76

23 **Greninja**

→ p. 21
Pattern on p. 69

07 **Psyduck**

→ p. 10
Pattern on p. 54

18 **Piplup**

→ p. 18
Pattern on p. 48

20 **Oshawott**

→ p. 19
Pattern on p. 66

26 **Popplio**

→ p. 22
Pattern on p. 72

05 **Squirtle**

→ p. 8
Pattern on p. 52

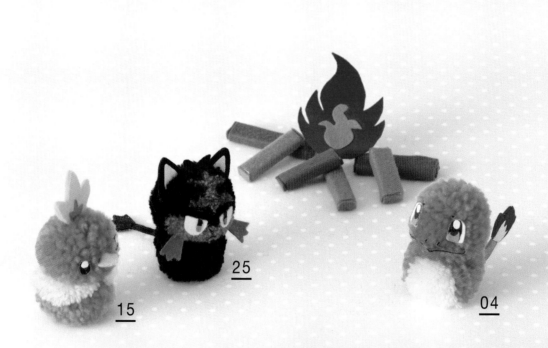

FIRE
TYPE

Torchic / Litten
Charmander
Victini

25 **Litten**
→ p. 22
Pattern on p. 71

15 **Torchic**
→ p. 16
Pattern on p. 62

04 **Charmander**
→ p. 8
Pattern on p. 51

2011

✕

Pokémon the Movie: Black—Victini
Pokémon the Movie: Black—Reshiram

Ash has arrived in Eindoak Town. There he meets Victini, who is lured out by its favorite macarons. But because of a young man named Damon who plots to use Victini's powers, Eindoak Town becomes involved in an unusual, never-before-seen incident.

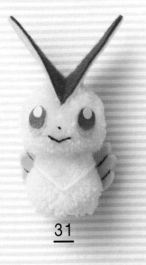

31

31 Victini

A Pokémon that brings victory. It is said that a Trainer who befriends Victini will win every battle. By making the "V" ears look cool, you too may be able to win every time!
Pattern on p. 77

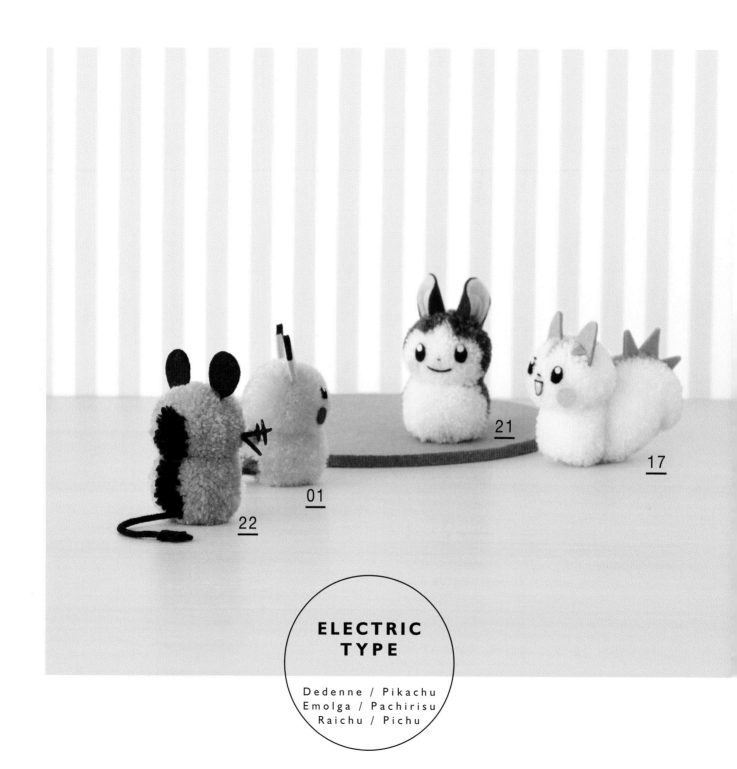

ELECTRIC TYPE

Dedenne / Pikachu
Emolga / Pachirisu
Raichu / Pichu

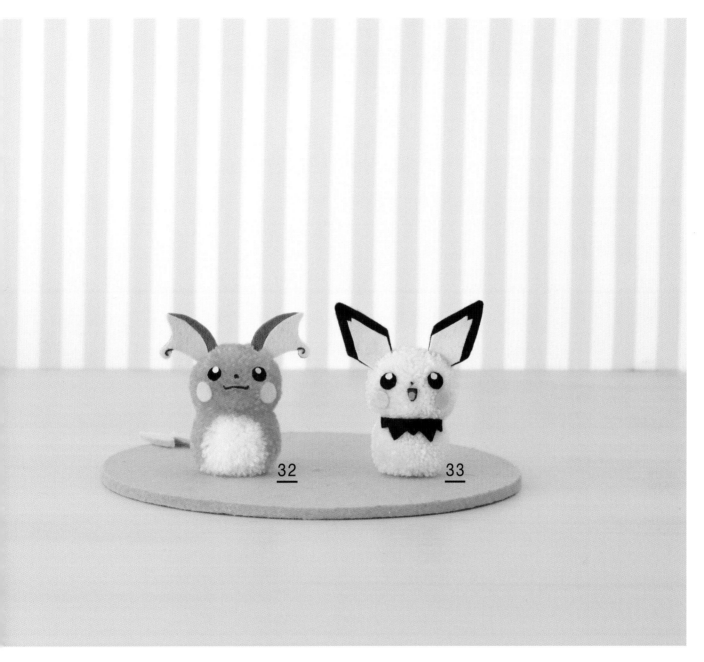

32 Raichu

An evolved form of Pikachu that can store 100,000 volts of electricity. However, if it stores too much electricity, it becomes aggressive. Make one and put it next to Pikachu!

Pattern on p. 78

33 Pichu

The pre-evolved form of Pikachu. It isn't very good at storing electricity, so at times it may accidentally discharge some when startled. To make it look cute, be careful where you place the eyes and cheeks.

Pattern on p. 79

22 Dedenne

→ p. 20

Pattern on p. 68

01 Pikachu

→ p. 6

Pattern on p. 40

21 Emolga

→ p. 19

Pattern on p. 67

17 Pachirisu

→ p. 18

Pattern on p. 64

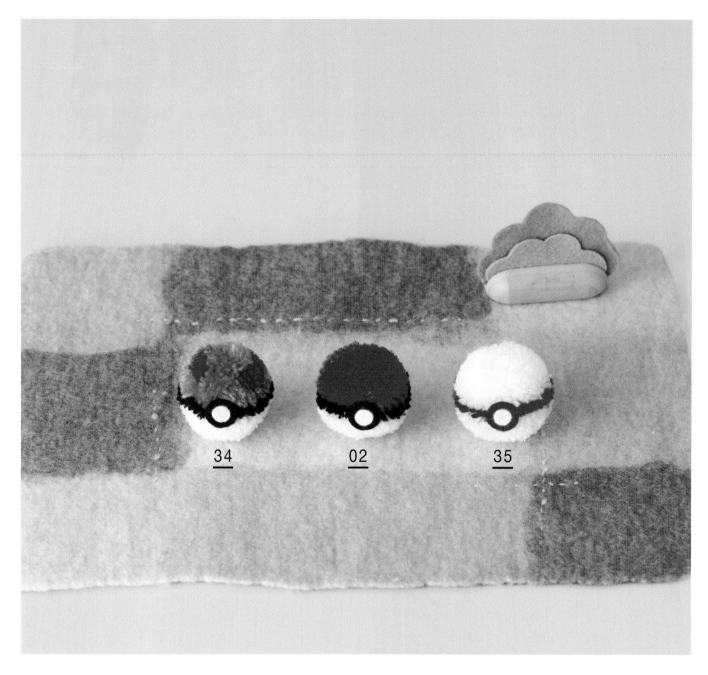

34 Great Ball

More efficient than the regular Poké Ball in catching Pokémon. Making the red bands may be a bit challenging.

Pattern on p. 47

35 Premier Ball

A somewhat rare ball created for a special event. Trim it carefully so you can make it nice and round.

Pattern on p. 47

02 Poké Ball

→ p. 7

Pattern on p. 46

How to Make Pompom Pokémon

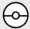

In this section, you will find the patterns for making pompom Pokémon.
Check out the supplies you will need and the basic instructions, then
make as many different Pokémon as you can. Your goal: to become a
master of pompom Pokémon!

Supplies and Tools

First, gather your supplies and tools.
You can get yarn and felt at a craft store.
*Materials pictured courtesy of Clover Mfg. Co., Ltd. and Hamanaka Co., Ltd.

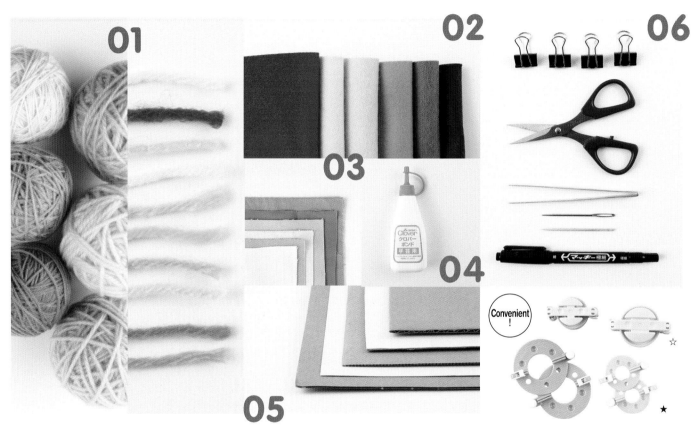

01. Yarn ★

All of the pompoms are made mostly of yarn. Check "Learning About Yarns" on p. 38 and use your favorite yarns.

02. Felt

Use felt for parts like the ears and mouth.

03. Fabric (Cotton Broadcloth)

Use this as the base for little parts and felt parts. A higher thread count is better.

04. Handicraft Glue ☆

Use this to attach the various parts.

05. Cardboard

You can use cardboard to make your own pompom maker.

06. Additional Tools

Binder clips, scissors, tweezers, wool needle, toothpicks, permanent marker (black superfine)

☆ Clover Super Pompom Makers, 35 mm and 45 mm

★ Hamanaka Kurukuru Pompom Makers, 3.5 cm and 5.5 cm

Reading the Patterns

Here's how to read the patterns for making the pompom Pokémon. Once you've mastered this, you can make any pompom Pokémon.

Difficulty

This shows the degree of difficulty. Check the level before you start!

Supplies

All yarn in this book is from Hamanaka. Yarn is presented by type, color and color code. All you need is one ball of each color. (See p. 38.)

Tools

Find the details on the page to the left.

How to Make

If there is anything you don't understand, please refer to "Basic Instructions" (pp. 40–49).

Tips

Look here for hints on how to make your pompom Pokémon cuter.

How to Wrap the Yarn

This shows you how many times to wrap your yarn. Some call for "single strand," and some are "double strand," so please read this section carefully. If you are using a single strand where it calls for double, wrap the yarn around twice as many times as the directions call for.

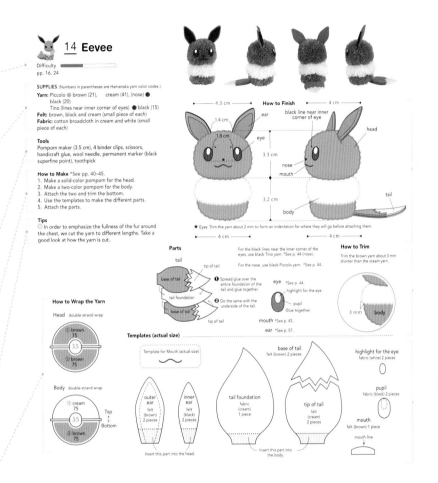

14 **Eevee**

Difficulty
pp. 16, 24

SUPPLIES (Numbers in parentheses are Hamanaka yarn color codes.)
Yarn: Piccolo ● brown (21), ○ cream (41), (nose) ●
black (20)
Tino (lines near inner corner of eyes) ● black (15)
Felt: brown, black and cream (small piece of each)
Fabric: cotton broadcloth in cream and white (small piece of each)

Tools
Pompom maker (3.5 cm), 4 binder clips, scissors, handicraft glue, wool needle, permanent marker (black superfine point), toothpick

How to Make *See pp. 40–45.
1. Make a solid-color pompom for the head.
2. Make a two-color pompom for the body.
3. Attach the two and trim the bottom.
4. Use the templates to make the different parts.
5. Attach the parts.

Tips
◎ In order to emphasize the fullness of the fur around the chest, we cut the yarn to different lengths. Take a good look at how the yarn is cut.

How to Finish

Double-check the size of your Pokémon, the distance between the eyes, etc.

Parts

This shows detailed instructions for making the parts.

Templates

Copy these exactly to size and use them as patterns. See p. 43 for the correct way to copy the templates.

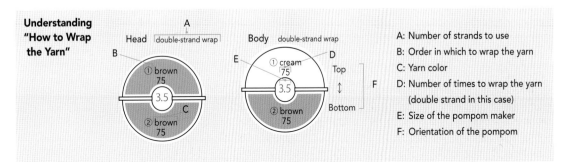

Understanding "How to Wrap the Yarn"		
A:	Number of strands to use	
B:	Order in which to wrap the yarn	
C:	Yarn color	
D:	Number of times to wrap the yarn (double strand in this case)	
E:	Size of the pompom maker	
F:	Orientation of the pompom	

POMPOM BASICS

Learning About Yarns

Compare the yarn you have with the actual-size pictures here. If the sizes are the same, you can wrap your yarn around the pompom maker the same number of times. If the sizes are different, change the number of wraps accordingly. Use the chart below to adjust the number.

Guide to the Number of Times to Wrap Yarn (to Make One Single-Color Pompom)

Actual Size

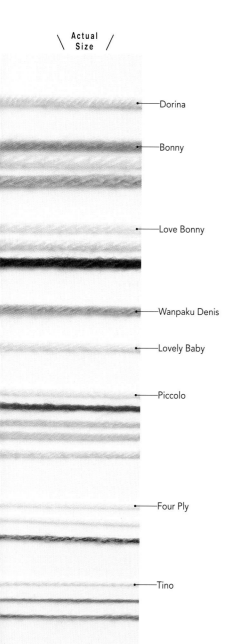

- Dorina
- Bonny
- Love Bonny
- Wanpaku Denis
- Lovely Baby
- Piccolo
- Four Ply
- Tino

Product Name	Type	Size of Pompom Maker 3.5 cm	5.5 cm
Dorina 50 g ball, about 45 m	Bulky	single strand (40 / 40) = about 4 g 40 x 2	single strand (100 / 100) = about 13 g 100 x 2
Bonny 50 g ball, about 60 m	Heavy	single strand (45 / 45) = about 4 g 45 x 2	single strand (120 / 120) = about 13 g 120 x 2
Love Bonny 40 g ball, about 70 m	Worsted	double strand (35 / 35) = about 4 g 35 x 2	double strand (80 / 80) = about 11 g 80 x 2
Wanpaku Denis 50 g ball, about 120 m	Worsted	double strand (60 / 60) = about 6 g 60 x 2	double strand (160 / 160) = about 18 g 160 x 2
Lovely Baby 40 g ball, about 105 m	Worsted	double strand (60 / 60) = about 4 g 60 x 2	double strand (160 / 160) = about 15 g 160 x 2
Piccolo 25 g ball, about 90 m	Sport	double strand (75 / 75) = about 4 g 75 x 2	double strand (170 / 170) = about 10 g 170 x 2
Four Ply 50 g ball, about 205 m	Sport	double strand (110 / 110) = about 4 g 110 x 2	double strand (300 / 300) = about 15 g 300 x 2
Tino 25 g ball, about 190 m	Lace	double strand (175 / 175) = about 4 g 175 x 2	double strand (470 / 470) = about 15 g 470 x 2

☆ Numbers in the circle denote number of wraps.
☆ Number of wraps will change somewhat depending on the item you are working on.
☆ Chart is based on Hamanaka-brand yarn.

How to Make a Pompom Maker

Let's create a pompom maker for making your pompoms.
All you need is some cardboard, glue and a pair of scissors!

Supplies: Cardboard

Tools
Scissors and glue

Tips
◎ To copy the pattern onto the cardboard, use tracing paper to trace the diagram or make a photocopy. Cut out the diagram, then trace its outline onto the cardboard. *See p. 43.

How to Make

1. Copy your patterns and make 4 "A" cardboard pieces and 2 "B" pieces.

2. Copy the fold line onto the "A" pieces.

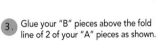

3. Glue your "B" pieces above the fold line of 2 of your "A" pieces as shown.

4. Fold the "A" pieces back along the fold lines.

You're done!

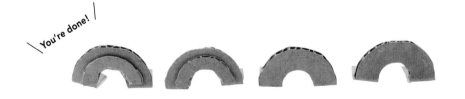

Templates (actual size) -

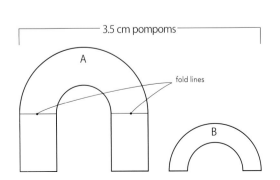

3.5 cm pompoms
A
fold lines
B

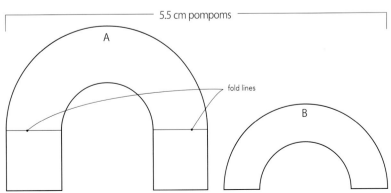

5.5 cm pompoms
A
fold lines
B

Pikachu

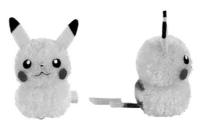 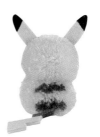 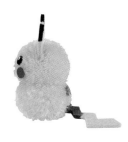

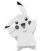

01 Pikachu

Difficulty ▭▭▭▭
pp. 6, 32

SUPPLIES (Numbers in parentheses are Hamanaka yarn color codes.)

Yarn: Tino ○ yellow (8), ● brown (13)
Piccolo (nose) ● black (20)
Felt: yellow (10 x 10 cm), brown, black and red
(small piece of each)
Fabric: cotton broadcloth in yellow and white
(small piece of each)

Tools
Pompom maker (3.5 cm), 4 binder clips, scissors,
handicraft glue, wool needle, permanent marker
(black superfine), toothpick

How to Make
1. Make the solid-color pompom for the head.
2. Make the patterned pompom for the body.
3. Attach the two, and trim the bottom.
4. Use the templates to make the different parts.
5. Attach the parts to the body and head.

1 Make a Single-Color Pompom for the Head

To Begin

1. Pull the yarn ends from the center and the outside of the ball.

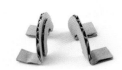

2. Match up a doubled-up pompom maker with a single one, with the glued-on piece sandwiched between them.

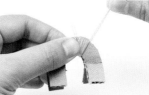

3. Hold the end of the yarns down with a finger, and wrap the double strands around the maker 175 times.

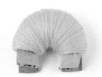

4. Yarn wrapped 175 times.

Ending the Wrap

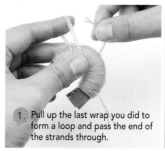

1. Pull up the last wrap you did to form a loop and pass the end of the strands through.

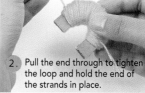

2. Pull the end through to tighten the loop and hold the end of the strands in place.

Make two.

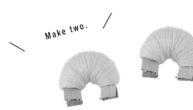

How to Wrap the Yarn

Head double-strand wrap

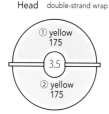

① yellow 175
3.5
② yellow 175

Body double-strand wrap

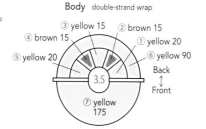

③ yellow 15 ② brown 15
④ brown 15 ① yellow 20
⑤ yellow 20 ⑥ yellow 90
3.5
⑦ yellow 175
Back
↕
Front

Forming a Ball

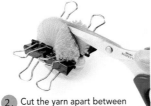

1. Put the yarn-wrapped pompom makers together to form a circle, fastening the cardboard ends together with the binder clips.

2. Cut the yarn apart between the two pompom makers.

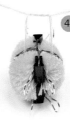

3. Slip a double strand of yarn between the cardboard and wrap it around twice. (If you are using thick yarn, use just one strand.)

4. Take the ends of the yarn, cross them, then wind one end twice through the loop, pulling the ends tight to tie. Tie it once more in the same way to make a firm knot.

Trim

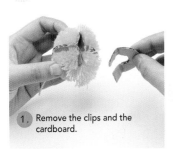

1. Remove the clips and the cardboard.

2. The ball will be slightly egg-shaped. Trim the yarn to make the pompom round, as shown by the dotted line.

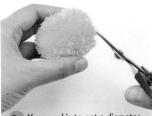

3. Your goal is to get a diameter of 4.2 cm.

\You're done!/

2 Make a Patterned Pompom for the Body

Upper Half (first layer)

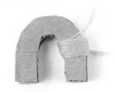
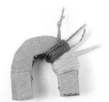

1. Wrap yellow yarn 20 times from the end of the maker.

2. Right next to it, wrap brown yarn 15 times.

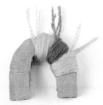
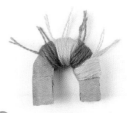

3. Next to the brown, wrap yellow yarn 15 times.

4. Next to the yellow, wrap brown yarn 15 times.

Upper Half (second layer)

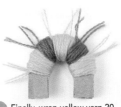
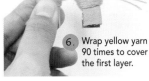

5. Finally, wrap yellow yarn 20 times. You may cut away any straggling yarn ends.

6. Wrap yellow yarn 90 times to cover the first layer.

Bottom Half

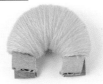

7. On your second pompom maker, wrap yellow yarn 175 times.

Connect them... ...cut and tie... ...and you're done.

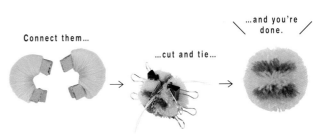

41

3 Connect the Pompoms and Trim the Bottom

Connect the Pompoms

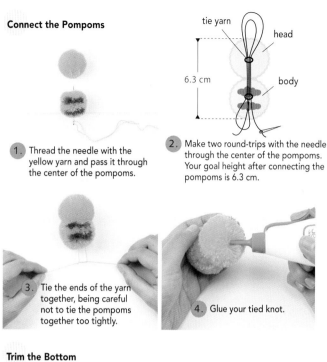

1. Thread the needle with the yellow yarn and pass it through the center of the pompoms.

2. Make two round-trips with the needle through the center of the pompoms. Your goal height after connecting the pompoms is 6.3 cm.

3. Tie the ends of the yarn together, being careful not to tie the pompoms together too tightly.

4. Glue your tied knot.

Trim the Bottom

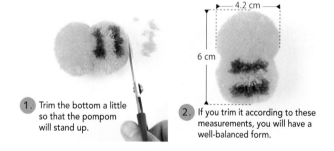

1. Trim the bottom a little so that the pompom will stand up.

2. If you trim it according to these measurements, you will have a well-balanced form.

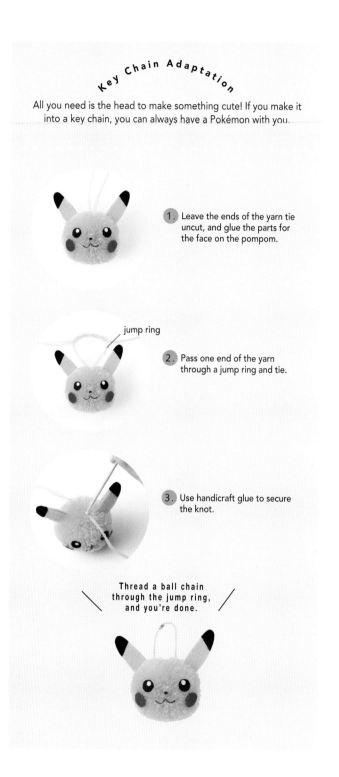

Key Chain Adaptation

All you need is the head to make something cute! If you make it into a key chain, you can always have a Pokémon with you.

1. Leave the ends of the yarn tie uncut, and glue the parts for the face on the pompom.

2. Pass one end of the yarn through a jump ring and tie.

3. Use handicraft glue to secure the knot.

Thread a ball chain through the jump ring, and you're done.

4 Trace the Templates to Prepare the Parts

For Felt

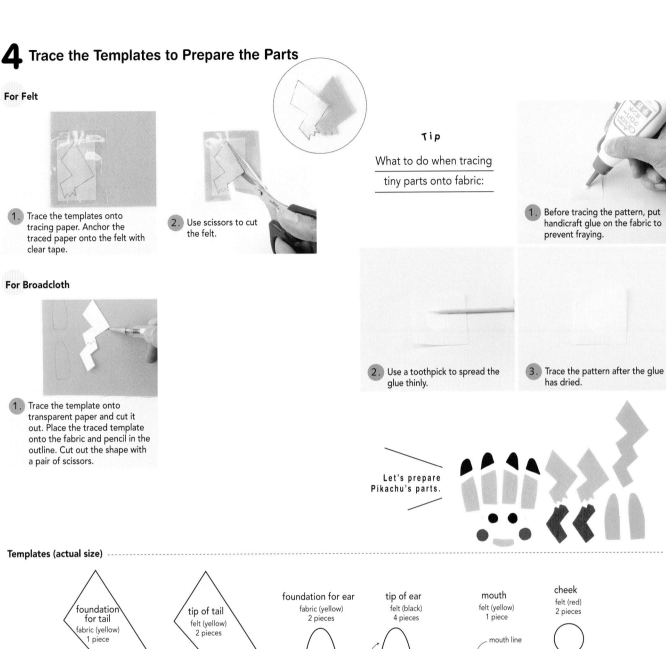

1. Trace the templates onto tracing paper. Anchor the traced paper onto the felt with clear tape.

2. Use scissors to cut the felt.

For Broadcloth

1. Trace the template onto transparent paper and cut it out. Place the traced template onto the fabric and pencil in the outline. Cut out the shape with a pair of scissors.

Tip

What to do when tracing tiny parts onto fabric:

1. Before tracing the pattern, put handicraft glue on the fabric to prevent fraying.

2. Use a toothpick to spread the glue thinly.

3. Trace the pattern after the glue has dried.

Let's prepare Pikachu's parts.

Templates (actual size)

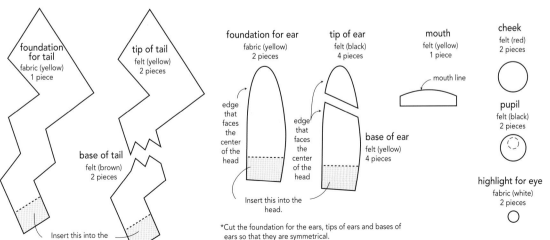

foundation for tail
fabric (yellow)
1 piece

tip of tail
felt (yellow)
2 pieces

base of tail
felt (brown)
2 pieces

Insert this into the body.

foundation for ear
fabric (yellow)
2 pieces

edge that faces the center of the head

Insert this into the head.

tip of ear
felt (black)
4 pieces

edge that faces the center of the head

base of ear
felt (yellow)
4 pieces

mouth
felt (yellow)
1 piece

mouth line

cheek
felt (red)
2 pieces

pupil
felt (black)
2 pieces

highlight for eye
fabric (white)
2 pieces

*Cut the foundation for the ears, tips of ears and bases of ears so that they are symmetrical.

5 Attaching the Parts

Tips

◎ The areas where the eyes and cheeks will go should be trimmed to about 2 mm. If you do not do this, the eyes will look like they are bulging out.

◎ Be careful with the direction of the ears. If you become confused, match them to the patterns and note which edge faces the center.

How to Finish

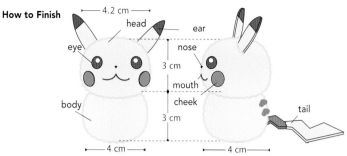

head, ear, eye, nose, 4.2 cm, 3 cm, mouth, body, cheek, 3 cm, tail, 4 cm, 4 cm

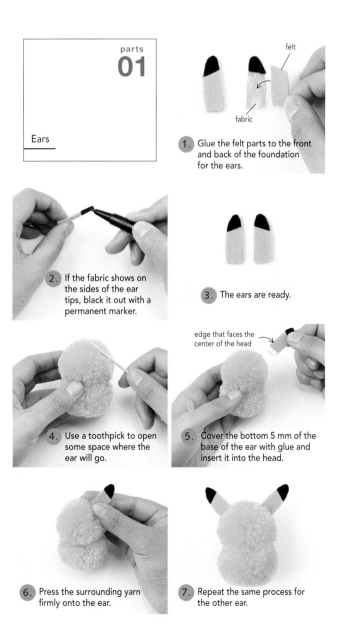

parts 01

Ears

1. Glue the felt parts to the front and back of the foundation for the ears.

felt, fabric

2. If the fabric shows on the sides of the ear tips, black it out with a permanent marker.

3. The ears are ready.

edge that faces the center of the head

4. Use a toothpick to open some space where the ear will go.

5. Cover the bottom 5 mm of the base of the ear with glue and insert it into the head.

6. Press the surrounding yarn firmly onto the ear.

7. Repeat the same process for the other ear.

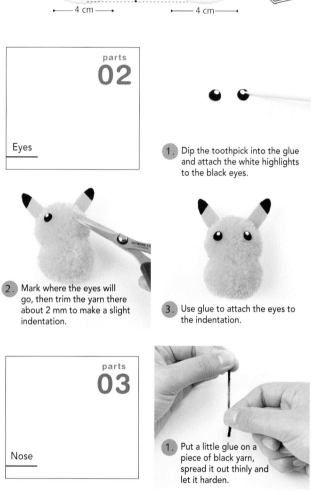

parts 02

Eyes

1. Dip the toothpick into the glue and attach the white highlights to the black eyes.

2. Mark where the eyes will go, then trim the yarn there about 2 mm to make a slight indentation.

3. Use glue to attach the eyes to the indentation.

parts 03

Nose

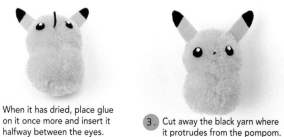

1. Put a little glue on a piece of black yarn, spread it out thinly and let it harden.

2. When it has dried, place glue on it once more and insert it halfway between the eyes.

3. Cut away the black yarn where it protrudes from the pompom.

parts
04

Mouth

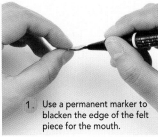

1. Use a permanent marker to blacken the edge of the felt piece for the mouth.

2. Put some glue on the felt piece.

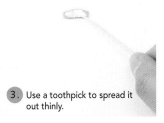

3. Use a toothpick to spread it out thinly.

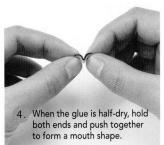

4. When the glue is half-dry, hold both ends and push together to form a mouth shape.

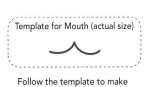

Template for Mouth (actual size)

Follow the template to make the mouth.

5. The mouth is ready.

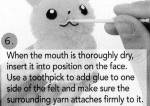

6. When the mouth is thoroughly dry, insert it into position on the face. Use a toothpick to add glue to one side of the felt and make sure the surrounding yarn attaches firmly to it.

parts
05

Cheeks

1. As you did for the eyes, trim about 2 mm from the area to form an indentation where the cheeks will go. Attach with glue.

parts
06

Tail

felt

fabric

1. Use glue to attach the felt pieces to both sides of the base of the tail.

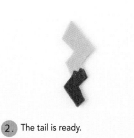

2. The tail is ready.

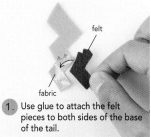

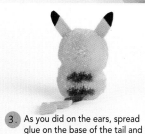

3. As you did on the ears, spread glue on the base of the tail and insert it.

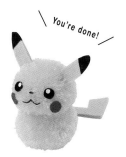

You're done!

BASIC INSTRUCTIONS

Part 2

Poké Ball

 ## 02 Poké Ball

Difficulty
pp. 7, 34

SUPPLIES (Numbers in parentheses are Hamanaka yarn color codes.)
Yarn: Piccolo ● red (26), ○ white (1), ● black (20)
Felt: black and white (small piece of each)

Tools
Pompom maker (3.5 cm), binder clips (4 pieces),
scissors, handicraft glue, toothpick

How to Make
1. Make a patterned pompom.
2. Adjust the shape.
3. Use the templates to make the different parts.
4. Attach the parts.

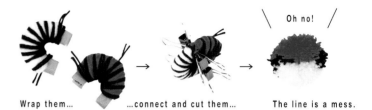

Wrap them... ...connect and cut them... Oh no! The line is a mess.

How to Fix the Line

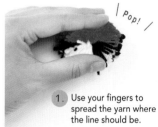

Pop!

1. Use your fingers to spread the yarn where the line should be.

How to Wrap the Yarn

Head double-strand wrap

② black
10
① red 65
3.5
③ white
65
④ black
10

Top
↕
Bottom

How to Finish

button
Trim the yarn about 2 mm to
form an indentation for where
the button will go before
attaching it.

4 cm

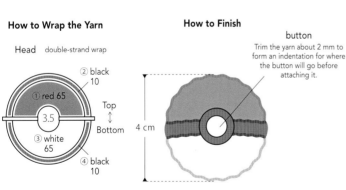

Parts

button
button (outer)
button (inner)

Attach with glue.

★ See p. 47 for templates.

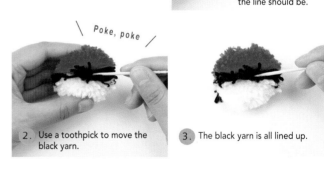

Poke, poke

2. Use a toothpick to move the black yarn.

3. The black yarn is all lined up.

You're done!

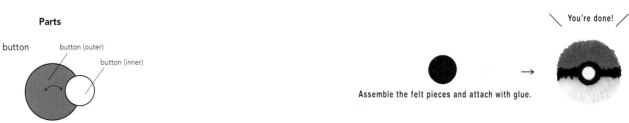

Assemble the felt pieces and attach with glue.

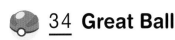 **34 Great Ball**

Difficulty ▬▬▬▭▭▭▭
p. 34

SUPPLIES (Numbers in parentheses are Hamanaka yarn color codes.)

Yarn: Piccolo ○ white (1), ◐ blue (23), ● black (20), ● red (26)
Felt: black and white (small piece of each)

How to Wrap the Yarn

Body double-strand wrap

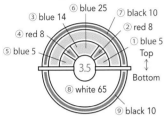

⑥ blue 25
③ blue 14 ⑦ black 10
④ red 8 ② red 8
⑤ blue 5 ① blue 5
 Top
 ↕
 Bottom
⑧ white 65
⑨ black 10

(center circle: 3.5)

Parts

button

button (outer)
button (inner)

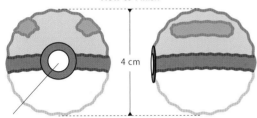

Attach with glue.

How to Finish

4 cm

button
Trim the yarn about 2 mm to form an
indentation for where you will glue the button.

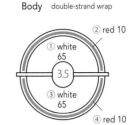 **35 Premier Ball**

Difficulty ▬▬▬▭▭▭▭
p. 34

SUPPLIES (Numbers in parentheses are Hamanaka yarn color codes.)

Yarn: Piccolo ○ white (1), ● red (26)
Felt: red and white (small piece of each)

How to Wrap the Yarn

Body double-strand wrap

② red 10
① white 65
③ white 65
④ red 10

(center circle: 3.5)

How to Finish

button
Trim the yarn about 2 mm
where you will glue the button
before attaching it.

4 cm

Parts

button

button (outer)
button (inner)

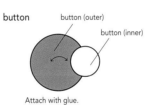

Attach with glue.

Templates (actual size)

button (outer)
Poké Ball, Great Ball = black felt
Premier Ball = red felt
1 piece

button (inner)
white felt
1 piece

Extra

Pompom Macarons

We will show you how to make the macarons that Victini (introduced on p. 31) loves. Make them in your favorite colors and display them together.

SUPPLIES (Numbers in parentheses are Hamanaka yarn color codes.)

Yarn:

A Piccolo ○ light pink (40),
 Four Ply ○ ecru (302)
B Four Ply ○ chartreuse (371)
 Four Ply ○ ecru (302)
C Piccolo ○ light blue (12)
 Four Ply ○ ecru (302)

Tools
Pompom maker (3.5 cm), 4 binder
clips, scissors

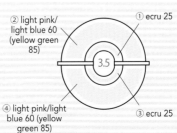

How to Wrap the Yarn
A/C, B in () double-strand wrap

② light pink/
light blue 60
(yellow green
85)

① ecru 25

③ ecru 25

④ light pink/light
blue 60 (yellow
green 85)

(center circle: 3.5)

How to Finish

3 cm

4.5 cm

◎ See "How to Fix the Line" on p. 46.

Piplup

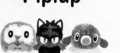

 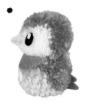

Here we will show you how to use the very convenient pompom-making tools available. You can use the cardboard ones too, just as you did to make Pikachu.

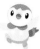 ## 18 Piplup

Difficulty
pp. 18, 28

SUPPLIES (Numbers in parentheses are Hamanaka yarn color codes.)

Yarn: Piccolo ● blue (23), ○ white (1)
Love Bonny ● light blue (116)
Felt: blue (5.5 x 4.5 cm), yellow, black and white (small piece of each)
Fabric: cotton broadcloth in white (small piece)

Tools
Kurukuru Pompom Maker (3.5 cm), scissors, handicraft glue, wool needle, toothpick

How to Make *See pp. 40–45.
1. Make a patterned pompom for the head.
2. Make a two-color pompom for the body.
3. Attach the two pompoms and trim the bottom.
4. Use the templates to make the different parts.
5. Attach the parts.

Head

Top Half / First Layer

1. Starting at the right end, wrap blue yarn 8 times, light-blue yarn 3 times and white yarn 10 times.

Top Half / Second Layer

2. Cover the first layer by wrapping blue yarn 6 times and white yarn 25 times.

Top Half / Third Layer

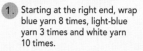

3. Wrap white yarn 15 times to cover the second layer.

Bottom Half

4. Wrap blue yarn 75 times around the other half of the pompom maker.

Body

Top Half

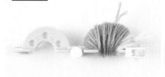

1. Starting at the right end, wrap light-blue yarn 8 times and blue yarn 58 times.

Bottom Half

2. Wrap light-blue yarn 35 times around the other half of the pompom maker.

How to Wrap the Yarn

Head double-strand wrap

⑤ white 25 ⑥ white 15
② light blue 3
③ white 10
① blue 8
④ blue 6
3.5
Front
Back
⑦ blue 75

Body double-strand wrap

① light blue 8
② blue 58
3.5
Back
Front
③ light blue 35

\ Front / \ Back /

How to Finish

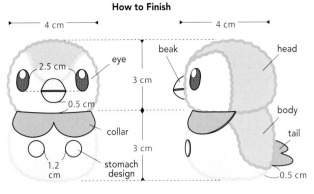

4 cm

2.5 cm — eye

0.5 cm

collar

1.2 cm

stomach design

4 cm — beak / head

3 cm

body

tail

3 cm

0.5 cm

★ Trim the yarn about 2 mm to form an indentation before attaching parts.

Beak

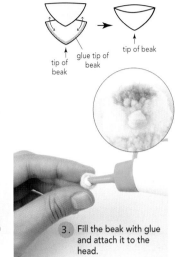

tip of beak / glue tip of beak / tip of beak

1. Glue the two sides of the beak pieces together to form a cup shape.

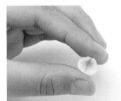

2. When the glue is half-dry, pinch the sides together to open up the center.

3. Fill the beak with glue and attach it to the head.

Parts

tail

Glue them together.

eye
highlight
pupil

Attach these with glue.

*See p. 44.

Templates (actual size)

Beak
felt (yellow) 2 pieces

tip of beak

tail
felt (blue) 2 pieces

Insert this part into head.

collar
felt (blue) 1 piece

Spread glue over the entire back side to attach.

highlight for the eye
fabric (white)
2 pieces

stomach pattern
felt (white)
2 pieces

pupil
felt (black)
2 pieces

You're done!

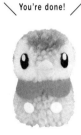

see p. 44.

Extra

Pompom Hearts

We will show you how to make the hearts that you saw on p. 25.
You can easily make them just by changing the way you trim the pompom.

A

B

SUPPLIES (Numbers in parentheses are Hamanaka yarn color codes.)

Yarn:
A: Four Ply light yellow (323)
B: Piccolo light pink (40)

Tools
Pompom maker (3.5 cm), 4 binder clips, scissors

How to Wrap the Yarn
A, B in () double-strand wrap

① light yellow 110 (light pink 75)

3.5

② light yellow 110 (light pink 75)

How to Finish

4 cm

4.5 cm

03 Bulbasaur

Difficulty ▰▰▰▰▰▰▰▰▱▱
pp. 8, 26

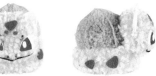

SUPPLIES (Numbers in parentheses are Hamanaka yarn color codes.)

Yarn: Dorina mint green (55)
Piccolo yellow green (9)
Tino (lines on nose and near inner corner of eyes) ● black (15)
Felt: mint green, white and marine blue (small piece of each)
Fabric: cotton broadcloth in red and white (small piece of each)

Tools

Pompom maker (3.5 cm, 5.5 cm), 4 binder clips, scissors, handicraft glue, wool needle, permanent marker (black superfine point), toothpick, tweezers

How to Make *See pp. 40–45.

1. Make a solid-color pompom for the head.
2. Make a two-color pompom for the body.
3. Attach the pompoms and trim the bottom.
 *Insert the needle from the rear of the seed on Bulbasaur's back through to the head, then back to the seed. (Refer to "How to Finish" illustration.)
4. Use the templates to make the different parts.
5. Attach the parts.

Tips

◎ The body pompom is made by trimming the body and seed. First, check the positioning and dimensions of each piece, then use the scissors to carefully trim.

How to Wrap the Yarn

Head single-strand wrap

① mint green 40
(3.5)
② mint green 40

★ Dorina (mint green) is a thick, firm yarn. After making the pompom, use a toothpick to unravel the yarn.

Body
yellow green: double-strand wrap
mint green: single-strand wrap

① yellow green 170
(5.5)
② mint green 100

Top ↕ Bottom

How to Finish

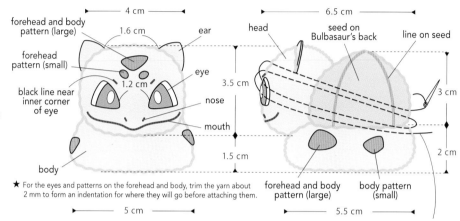

forehead and body pattern (large)
1.6 cm
ear
forehead pattern (small)
black line near inner corner of eye
1.2 cm
eye
nose
mouth
body
4 cm
3.5 cm
1.5 cm
5 cm

head
seed on Bulbasaur's back
line on seed
6.5 cm
3 cm
2 cm
forehead and body pattern (large)
body pattern (small)
5.5 cm

Sew the head and body pompoms together.

★ For the eyes and patterns on the forehead and body, trim the yarn about 2 mm to form an indentation for where they will go before attaching them.

How to Trim

= area to be trimmed

head
Front Side
3.5 cm
4 cm 3 cm

body, seed on its back

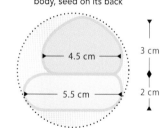

4.5 cm
5.5 cm
3 cm
2 cm

lines on the seed

Put some glue on the yarn (yellow green) and attach. (Using tweezers makes it easier.)

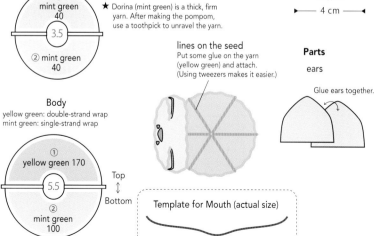

Template for Mouth (actual size)

Parts

ears

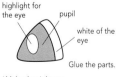

Glue ears together.

forehead and pattern on body

Refer to the photo image and the "How to Finish" section above.

left eye

highlight for the eye
pupil
white of the eye
Glue the parts.

*Make the right eye symmetrical to the left.
*See p. 44.

Use black Tino yarn for black line near inner eyes and nose.

*See p. 44 (nose).

mouth

❶ Draw a line with the permanent marker.

❷ Apply glue to entire length and carefully create the shape before the glue dries.

*See p. 45.

★ Templates are on p. 55.

04 Charmander

Difficulty [████████░░░░░]
pp. 8, 30

SUPPLIES (Numbers in parentheses are Hamanaka yarn color codes.)

Yarn: Bonny ⬤ orange (434)
Piccolo cream (41)
Tino (lines on nose and near inner corner of eyes)
⬤ black (15)
Felt: orange, red and white (small piece of each)
Fabric: cotton broadcloth in cream, white, blue green, orange and black (small piece of each)

Tools
Pompom maker (3.5 cm), 4 binder clips, scissors, handicraft glue, wool needle, permanent marker (black superfine point), toothpicks

How to Make *See pp. 40–45.
1. Make a solid-color pompom for the head.
2. Make a patterned pompom for the body.
3. Attach the two and trim the bottom.
4. Use the templates to make the different parts.
5. Attach the parts.

Tips
◎ When connecting the two pompoms, check the positioning of the stomach.

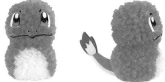

How to Finish

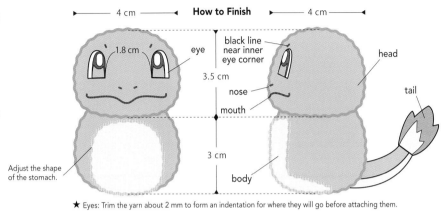

← 4 cm → ← 4 cm →

1.8 cm — eye
black line near inner eye corner
3.5 cm
nose
head
mouth
tail
3 cm
body
Adjust the shape of the stomach.
← 4 cm → ← 4 cm →

★ Eyes: Trim the yarn about 2 mm to form an indentation for where they will go before attaching them.

How to Wrap the Yarn

Head single-strand wrap

① orange 45
3.5
② orange 45

Body orange: single-strand wrap
cream: double-strand wrap

① orange 45
3.5
② orange 45

Back ↕ Front

② cream 40 ③ orange 20

How to Trim

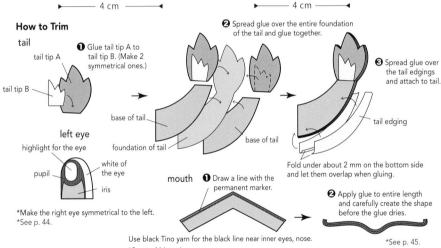

tail

tail tip A
tail tip B

❶ Glue tail tip A to tail tip B. (Make 2 symmetrical ones.)

base of tail
foundation of tail

❷ Spread glue over the entire foundation of the tail and glue together.

base of tail
base of tail

❸ Spread glue over the tail edgings and attach to tail.

tail edging

Fold under about 2 mm on the bottom side and let them overlap when gluing.

left eye

highlight for the eye
pupil
white of the eye
iris

*Make the right eye symmetrical to the left.
*See p. 44.

mouth ❶ Draw a line with the permanent marker.

❷ Apply glue to entire length and carefully create the shape before the glue dries.

*See p. 45.

Use black Tino yarn for the black line near inner eyes, nose.
*See p. 44 (nose).

Templates (actual size)

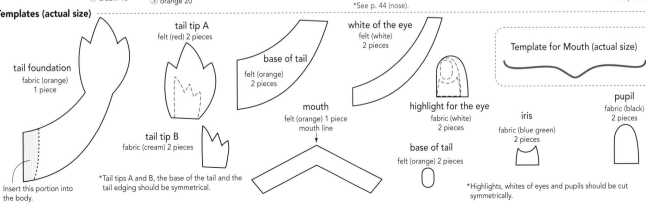

tail foundation
fabric (orange) 1 piece

Insert this portion into the body.

tail tip A
felt (red) 2 pieces

tail tip B
fabric (cream) 2 pieces

*Tail tips A and B, the base of the tail and the tail edging should be symmetrical.

base of tail
felt (orange) 2 pieces

mouth
felt (orange) 1 piece
mouth line

white of the eye
felt (white) 2 pieces

highlight for the eye
fabric (white) 2 pieces

base of tail
felt (orange) 2 pieces

iris
fabric (blue green) 2 pieces

*Highlights, whites of eyes and pupils should be cut symmetrically.

pupil
fabric (black) 2 pieces

Template for Mouth (actual size)

51

05 Squirtle

Difficulty ▰▰▰▰▱

pp. 8, 29

 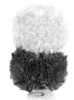 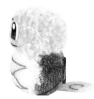

SUPPLIES (Numbers in parentheses are Hamanaka yarn color codes.)

Yarn: Dorina mint green (55)
Piccolo cream (41), ● brown (21),
○ white (1)
Tino (lines on nose and near inner corner
of eyes, patterns on stomach and back)
● black (15), ● brown (13),
● dark brown (14)
Felt: mint green and white (small piece of each)
Fabric: cotton broadcloth in white, red and black
(small piece of each)

Tools

Pompom maker (3.5 cm), 4 binder clips, scissors,
handicraft glue, wool needle, permanent marker
(black superfine point), toothpick, tweezers

How to Make *See pp. 40–45.

1. Make a solid-color pompom for the head.
2. Make a patterned pompom for the body.
3. Attach the two and trim the bottom.
4. Use the templates to make the different parts.
5. Attach the parts.

Tips

◎ The patterns on the stomach and back are
made with yarn. Using tweezers will make
placement easier.

How to Finish

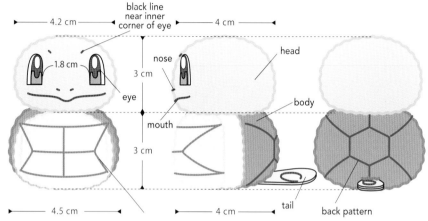

★ Eyes: Trim the yarn about 2 mm to form an
indentation for where they will go before
attaching them.

stomach pattern
Spread glue over brown
Tino yarn and attach.
(Using tweezers will make it easier.)

Spread glue over dark-brown Tino yarn and
attach.

*Form the central hexagon before gluing the
radiating lines.

Use black Tino yarn for the lines near the inner corner of the eyes and for the nose.
*See p. 44 (nose).

Parts

left eye *Make right eye symmetrical to left.

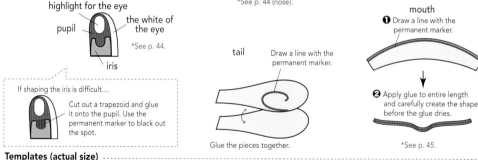

tail
Draw a line with the
permanent marker.

Glue the pieces together.

mouth
❶ Draw a line with the
permanent marker.

❷ Apply glue to entire length
and carefully create the shape
before the glue dries.

*See p. 45.

If shaping the iris is difficult…
Cut out a trapezoid and glue
it onto the pupil. Use the
permanent marker to black out
the spot.

How to Wrap the Yarn

Head single-strand wrap

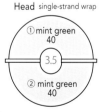
① mint green 40
② mint green 40
3.5

★ Dorina (mint green) is a thick, firm yarn.
After making the pompom, use a toothpick
to unravel the yarn.

Body double-strand wrap

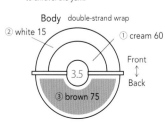
② white 15
① cream 60
③ brown 75
3.5
Front ↕ Back

Templates (actual size)

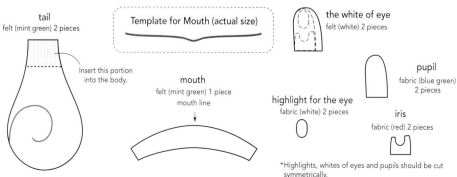

tail
felt (mint green) 2 pieces

Insert this portion
into the body.

Template for Mouth (actual size)

mouth
felt (mint green) 1 piece
mouth line

the white of eye
felt (white) 2 pieces

highlight for the eye
fabric (white) 2 pieces

pupil
fabric (blue green)
2 pieces

iris
fabric (red) 2 pieces

*Highlights, whites of eyes and pupils should be cut
symmetrically.

06 Togepi

Difficulty ▰▰▰▰▰▱▱▱

p. 10

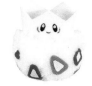

SUPPLIES (Numbers in parentheses are Hamanaka yarn color codes.)

Yarn: Piccolo cream (41), ○ white (1)
Felt: lemon yellow (5 x 16 cm), red and blue (small piece of each)
Fabric: cotton broadcloth in white and black (small piece of each)

Tools

Pompom maker (5.5 cm), 4 binder clips, scissors, handicraft glue, wool needle, permanent marker (black superfine point), toothpick

How to Make *See pp. 40–45.

1. Make a patterned pompom.
2. Trim the bottom.
3. Use the templates to make the different parts.
4. Attach the parts.

Tips

◎ Please follow the instructions for trimming the cream-color part carefully so that the felt surrounding the face will attach neatly.

How to Wrap the Yarn

Body double-strand wrap

④ white 50
③ white 20
② cream 80
① white 20
5.5
Top
Bottom
⑤ white 170

How to Trim

= area to be trimmed

1.8cm
5cm
3.2cm
cream 3.5cm
white
5.5cm

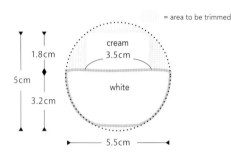

Parts

face wrap

❶ To make it sturdier, spread glue over the entire back side of the felt and let it dry.

❷ Spread another layer of glue on top and attach it to the yarn on the body.

eye

highlight for the eye
pupil
Glue together.
*See p. 44.

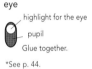

rectangular design for body

Glue.
A
B

triangular design for body (large)

Glue.
C
D
*3 red, 5 blue

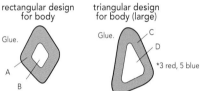

How to Finish

Front

eye
black line near eye
mouth

5.8 cm
rectangular design for body

Front ←

Back

Overlap and glue.

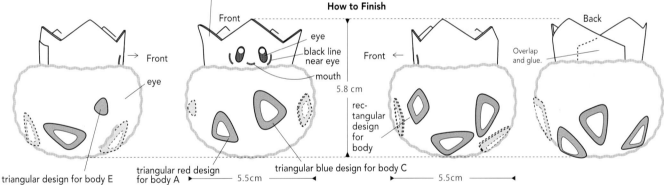

triangular design for body E

triangular red design for body A

triangular blue design for body C

Front →
eye

5.5cm 5.5cm

*Draw the black lines by the eyes and for the mouth with the permanent marker.

Templates (actual size)

pupil
fabric (black)
2 pieces

highlight for the eye
fabric (white) 2 pieces

triangular design for body C
felt (red) 3 pieces, (blue) 5 pieces

rectangular design for body B
fabric (white) 1 piece

rectangular design for body A
felt (red) 1 piece

face wrap
felt (lemon yellow) 1 piece

large triangular design for body D
fabric (white) 8 pieces

triangular design for body E
felt (red) 1 piece

Overlap and glue this section.

Overlap and glue this section.

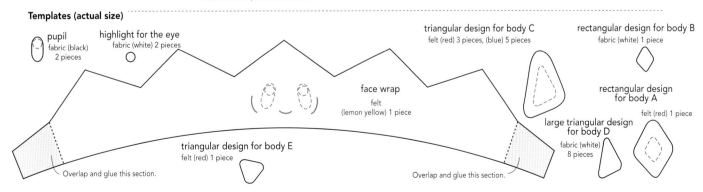

07 Psyduck

Difficulty
pp. 10, 28

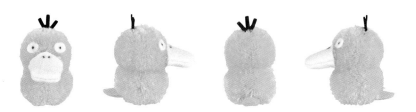

SUPPLIES (Numbers in parentheses are Hamanaka yarn color codes.)
Yarn: Tino yellow (8)
Felt: lemon yellow (5 x 9 cm), black, yellow and white (small piece of each)
Thread: white (small amount)

Tools
Pompom maker (3.5 cm), 4 binder clips, scissors, handicraft glue, wool needle, permanent marker (black superfine point), toothpick, masking tape, sewing needle

How to Make *See pp. 40–45.
1. Make single-color pompoms for the head and body.
2. Attach the two and trim the bottom.
3. Use the templates to make the different parts.
4. Attach the parts.

Tips
◎ You must sew fine stiches into the beak or it will not be properly shaped when you turn it right side out.

How to Finish

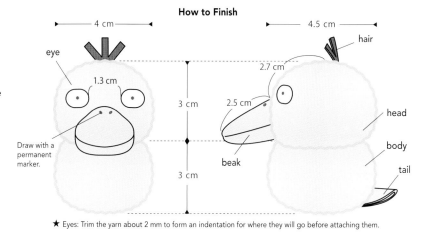

eye

Draw with a permanent marker.

4 cm

1.3 cm

3 cm

3 cm

hair

4.5 cm

2.7 cm

2.5 cm

beak

head

body

tail

★ Eyes: Trim the yarn about 2 mm to form an indentation for where they will go before attaching them.

4 cm 4.5 cm

Parts

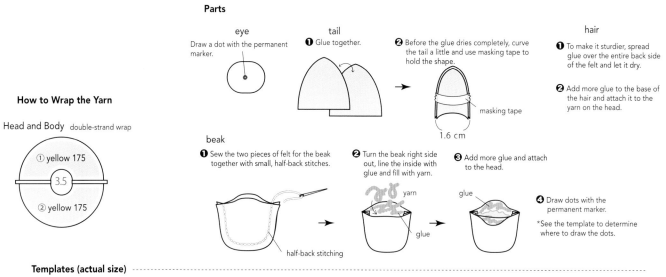

eye
Draw a dot with the permanent marker.

tail
❶ Glue together.
❷ Before the glue dries completely, curve the tail a little and use masking tape to hold the shape.
masking tape
1.6 cm

hair
❶ To make it sturdier, spread glue over the entire back side of the felt and let it dry.
❷ Add more glue to the base of the hair and attach it to the yarn on the head.

beak
❶ Sew the two pieces of felt for the beak together with small, half-back stitches.
half-back stitching
❷ Turn the beak right side out, line the inside with glue and fill with yarn.
yarn
glue
❸ Add more glue and attach to the head.
glue
❹ Draw dots with the permanent marker.
*See the template to determine where to draw the dots.

How to Wrap the Yarn

Head and Body double-strand wrap

① yellow 175
3.5
② yellow 175

Templates (actual size)

eye
felt
(white) 2 pieces

beak
felt
(lemon yellow)
2 pieces

hair
felt (black) 1 piece

Insert this part into the head.

tail
felt (yellow) 2 pieces

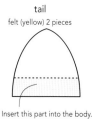

Insert this part into the body.

08 Mew

Difficulty
p. 11

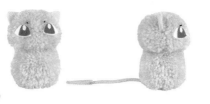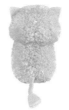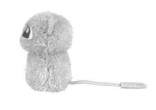

SUPPLIES (Numbers in parentheses are Hamanaka yarn color codes.)

Yarn: Four Ply ○ light pink (305)
Tino (black marks near inner corner of eyes)
● black (15)
Felt: light pink and white (small piece of each)
Fabric: cotton broadcloth in white and blue (small amount of each)
Colored cotton string (thin): light pink (5 cm)

Tools

Pompom maker (3.5 cm), 4 binder clips, scissors, handicraft glue, wool needle, toothpick

How to Make *See pp. 40–45.

1. Make single-color pompoms for the head and body.
2. Attach the two and trim the bottom.
3. Use the templates to make the different parts.
4. Attach the parts.

Tips

◎ When trimming the face, giving it a pointy jaw line will bring out the Mew look. Use the picture to guide you.

How to Finish

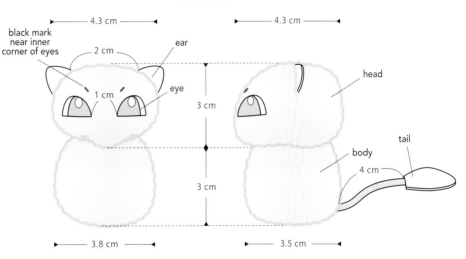

black mark near inner corner of eyes
4.3 cm
2 cm
ear
1 cm
eye
4.3 cm
head
3 cm
3 cm
body
tail
4 cm
3.8 cm
3.5 cm

★ Eyes: Trim the yarn about 2 mm to form an indentation for where they will go before attaching them.

How to Wrap the Yarn

Head and Body double-strand wrap

① light pink 110
3.5
② light pink 110

Parts

ear
Glue together.

left eye
highlight for the eye
pupil
Glue.
the white of eye

*The right eye should be symmetrical to the left.
*See p. 44.

tail
❷ Glue the other tail tip over the string.
❶ Glue the colored string to the tail tip.
colored string

For black marks near inner corner of eyes, use black Tino yarn.
*See p. 44 (nose).

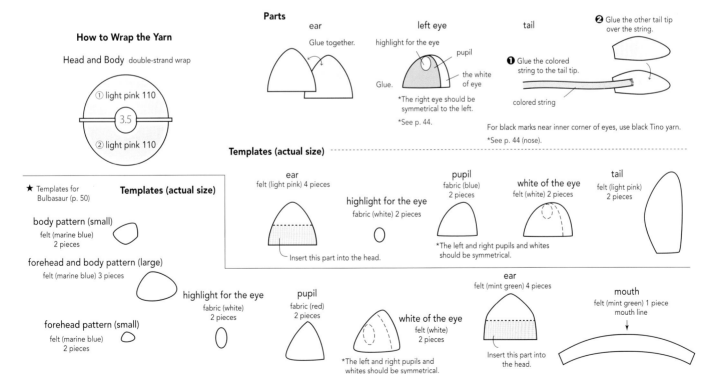

★ Templates for Bulbasaur (p. 50)

Templates (actual size)

body pattern (small)
felt (marine blue)
2 pieces

forehead and body pattern (large)
felt (marine blue) 3 pieces

forehead pattern (small)
felt (marine blue)
2 pieces

Templates (actual size)

ear
felt (light pink) 4 pieces
Insert this part into the head.

highlight for the eye
fabric (white) 2 pieces

pupil
fabric (blue)
2 pieces

white of the eye
felt (white) 2 pieces
*The left and right pupils and whites should be symmetrical.

tail
felt (light pink)
2 pieces

highlight for the eye
fabric (white)
2 pieces

pupil
fabric (red)
2 pieces

white of the eye
felt (white)
2 pieces
*The left and right pupils and whites should be symmetrical.

ear
felt (mint green) 4 pieces
Insert this part into the head.

mouth
felt (mint green) 1 piece
mouth line

09 Clefairy

Difficulty

p. 12

SUPPLIES (Numbers in parentheses are Hamanaka yarn color codes.)

Yarn: Piccolo ⚪ light pink (40), ⚫ dark pink (5)
(for curl on forehead and tail)
Felt: light pink, brown, black, dark pink
and red (small piece of each)
Fabric: cotton broadcloth in white and
light pink (small piece of each)
Thread: white (small amount)

Tools

Pompom maker (3.5 cm, 5.5 cm), 4 binder
clips, scissors, handicraft glue, permanent
marker (black superfine point), toothpick

How to Make *See pp. 40–45.

1. Make a single-color pompom.
2. Trim the bottom.
3. Make four small pompoms and attach.
4. Use the templates to make the
 different parts.
5. Attach the parts.

Parts

● Instructions for Making the Small Pompoms

❶ Wrap the yarn the designated number of times around one side of the pompom maker, cut the top and remove the yarn from the maker.

❷ Lay the yarn over a piece of thread, wrap the thread around twice and tie tightly.

thread

❸ The knot should be on the bottom.

If this part tends to separate, glue some strands together.

knot

You will glue this side to the large pompom.

eye
highlight for the eye
pupil
Glue together. *See p. 44.

mouth
fang
mouth
Glue together.
tongue
Outline the mouth with the permanent marker.

forehead puff
↤ 2.3 cm ↦
1.5 cm

tail
↤ 3 cm ↦
2 cm
(seen from above)

ear
❶ Trim a small pompom into a cone shape.
= sections to be trimmed away
2 cm
↤ 2.5 cm ↦

❷ Glue it to the head.
tip of ear
head
side of ear

❸ Glue the side of the ear first, then the ear tip. (Trim the yarn about 2 mm before you attach the ears.)

For the black lines by the eyes, *see p. 45 (mouth).

How to Finish

★ For the "How to Wrap" directions for the pompoms, see p. 57.

↤ 7.5 cm ↦

Glue a piece of dark-pink yarn to the forehead puff.

forehead puff

1.2 cm

cheek

mouth

line by eye

↤ 5.5 cm ↦

★ Eyes, cheeks, mouth, ears: Trim the yarn about 2 mm to form an indentation for where they will go before attaching them.

6.5 cm
5.5 cm

eye

body

tail

↤ 5 cm ↦
↤ 6.5 cm ↦

ear

2.3 cm

Draw lines with the permanent marker.

wing

Glue a piece of dark-pink yarn to the tail.

Back

Templates (actual size)

wing
felt (light pink) 2 pieces

tip of ear
felt (brown) 2 pieces

*The left and right wings should be symmetrical.

side of ear
felt (black) 2 pieces

highlight for the eye
fabric (white) 2 pieces

pupil
felt (black) 2 pieces

cheek
fabric (dark pink) 2 pieces

mouth
felt (red) 1 piece

tongue
fabric (light pink) 1 piece

fang
fabric (white) 1 piece

black line by eye
felt (light pink) 2 pieces

Template (actual size) for Black Line Under Eyes

*Make the left and right lines symmetrical.

10 Jigglypuff

Difficulty ▰▰▰▱▱▱▱

pp. 12, 25

SUPPLIES (Numbers in parentheses are Hamanaka yarn color codes.)
Yarn: Piccolo ⚪ light pink (40), (for puff on forehead)
⚫ dark pink (5)
Felt: light pink, black and white (small piece of each color)
Fabric: cotton broadcloth in white and mint green (small piece of each)
Thread: white (small amount)

Tools

Pompom maker (3.5 cm, 5.5 cm), 4 binder clips, scissors, handicraft glue, permanent marker (black superfine point), toothpick

How to Make *See pp. 40–45.

1. Make a single-color pompom.
2. Trim the bottom.
3. Make a small pompom and attach.
4. Use the templates to make the different parts.
5. Attach the parts.

Tips

◎ There is nothing to sew and there are only a few parts, so we recommend this for your first try.

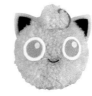 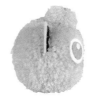 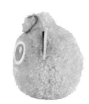

How to Finish

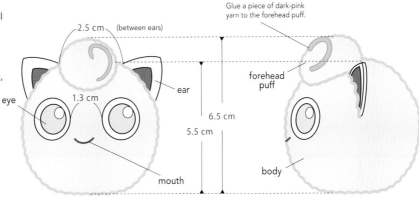

Glue a piece of dark-pink yarn to the forehead puff.

2.5 cm (between ears)

eye

1.3 cm

ear

6.5 cm

5.5 cm

forehead puff

body

mouth

5.5 cm

5.5 cm

★ Eyes: Trim the yarn about 2 mm to form an indentation for where they will go before attaching them.

★ Clefairy p. 56

How to Wrap the Yarn
Body double-strand wrap

① light pink 170

5.5

② light pink 170

double-strand wrap

light pink

3.5

forehead puff: 30 wraps (make 1)
tail: 40 wraps (make 1)
ear: 35 wraps (make 2)

How to Wrap

Body double-strand wrap

① light pink 170

5.5

② light pink 170

forehead puff double-strand wrap

light pink 30

3.5

Parts

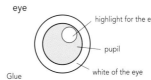

eye

highlight for the eye

pupil

white of the eye

Glue together. *See p. 44.

ear

inner ear

outer ear

Glue together.

mouth

❶ Draw a line with the permanent marker.

❷ Apply glue to entire length and carefully create the shape before the glue dries.

*See p. 45.

forehead puff

*See p. 56.

Templates (actual size)

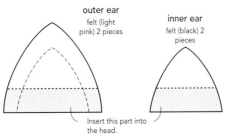

outer ear
felt (light pink) 2 pieces

Insert this part into the head.

inner ear
felt (black) 2 pieces

white of the eye
felt (white) 2 pieces

pupil
fabric (mint green) 2 pieces

Template for Mouth (actual size)

highlight for the eye
fabric (white) 2 pieces

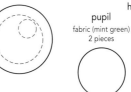

mouth
felt (light pink) 1 piece

11 Snorlax

Difficulty ▬▬▬▬
pp. 13, 25

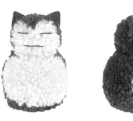

SUPPLIES (Numbers in parentheses are Hamanaka yarn color codes.)

Yarn: Love Bonny ● blue green (131), ○ beige (103)
Felt: blue green, beige and white (small piece of each)

Tools
Pompom maker (3.5 cm, 5.5 cm), 4 binder clips, scissors, handicraft glue, wool needle, permanent marker (black superfine point), toothpick, tweezers

How to Make *See pp. 40–45.
1. Make patterned pompoms for the head and body.
2. Attach the two and trim the bottom.
3. Use the templates to make the different parts.
4. Attach the parts.

Tips
◎ Make sure the head and body are properly aligned when connecting them.

How to Finish

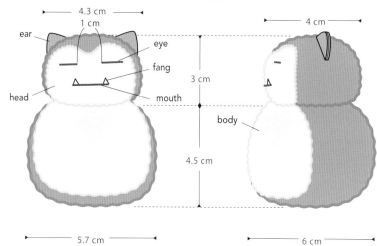

ear · 1 cm · eye · fang · mouth · head
4.3 cm · 3 cm · 4.5 cm · 5.7 cm
body · 4 cm · 6 cm

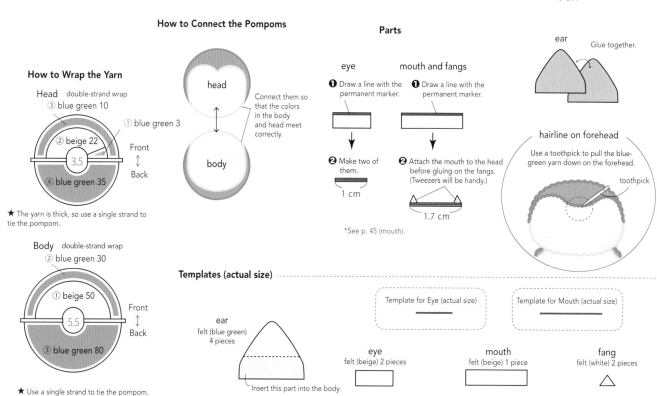

How to Connect the Pompoms

How to Wrap the Yarn

Head double-strand wrap
③ blue green 10
① blue green 3
② beige 22
3.5
④ blue green 35
Front ↕ Back

★ The yarn is thick, so use a single strand to tie the pompom.

Body double-strand wrap
② blue green 30
① beige 50
5.5
③ blue green 80
Front ↕ Back

★ Use a single strand to tie the pompom.

head

body

Connect them so that the colors in the body and head meet correctly.

Parts

eye
❶ Draw a line with the permanent marker.

❷ Make two of them.
1 cm

mouth and fangs
❶ Draw a line with the permanent marker.

❷ Attach the mouth to the head before gluing on the fangs. (Tweezers will be handy.)
1.7 cm

*See p. 45 (mouth).

ear
Glue together.

hairline on forehead
Use a toothpick to pull the blue-green yarn down on the forehead.
toothpick

Templates (actual size)

ear
felt (blue green)
4 pieces
Insert this part into the body.

Template for Eye (actual size)

Template for Mouth (actual size)

eye
felt (beige) 2 pieces

mouth
felt (beige) 1 piece

fang
felt (white) 2 pieces

12 Meowth

Difficulty ■■■■■□□□□
p. 14

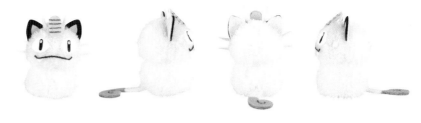

SUPPLIES (Numbers in parentheses are Hamanaka yarn color codes.)
Yarn: Tino ○ ecru (2)
Felt: ecru, white, yellow, black and ocher (small piece of each)
Fabric: cotton broadcloth in salmon pink, white and black (small piece of each)

Tools
Pompom maker (3.5 cm), 4 binder clips, scissors, handicraft glue, wool needle, permanent marker (black superfine point), toothpick, tweezers

How to Make *See pp. 40–45.
1. Make a single-color pompom for head and body.
2. Attach the two and trim the bottom.
3. Use the templates to make the different parts.
4. Attach the parts.

Tips
◎ Its whiskers are long, so you need to harden them in order for them to be straight. Don't forget to spread glue on the felt pieces and let them dry to strengthen them.

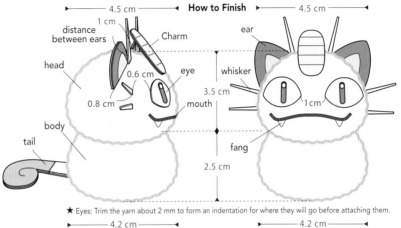

How to Finish

distance between ears — 4.5 cm — 1 cm — Charm — 4.5 cm — ear

head — 0.6 cm — eye — whisker — 3.5 cm — 1 cm

0.8 cm — mouth

body — fang — 2.5 cm

tail

★ Eyes: Trim the yarn about 2 mm to form an indentation for where they will go before attaching them.

— 4.2 cm — — 4.2 cm —

How to Wrap the Yarn

Head and Body double-strand wrap

① ecru 175
3.5
② ecru 175

left eye
highlight for the eye
pupil
Glue together.

*The right eye should be symmetrical to the left.
*See p. 44.

Charm
Draw lines with the permanent marker.
Glue together.

Parts

ear
outer ear (ecru)
outer ear (black)
inner ear
❶ Glue together.
❷ Glue together.

mouth and fangs
❶ Draw a line with the permanent marker.
❷ Apply glue to entire length and carefully create the shape before the glue dries.
❸ Attach the mouth to face before gluing the fangs on. (Tweezers will come in handy.)
*See p. 45.

whiskers
3 cm
3 cm
Use a square piece of felt. Spread glue over the felt. Let it dry before cutting.

tail
❶ Spread glue over the entire tail foundation and attach the parts.
base of tail
Use the permanent marker to draw the lines
foundation of tail
base of tail
tip of tail
❷ Attach bottom of tail too.

Templates (actual size)

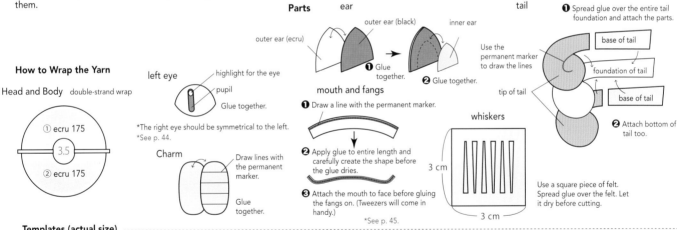

white of eye
felt (white) 2 pieces
*The dotted line shows positioning of pupil for the left eye.

pupil
fabric (black) 2 pieces

outer ear
felt (black and ecru) 2 pieces each
Insert this part into the head.

inner ear
fabric (salmon pink) 2 pieces

Template for Mouth (actual size)

Charm
felt (yellow) 2 pieces

tip of tail
felt (ocher) 2 pieces

base of tail
felt (white) 1 piece

Insert this part into the body.

mouth
felt (ecru) 1 piece
mouth line

highlight for the eye
fabric (white) 2 pieces
○

whiskers
felt (ecru) 6 pieces

fang
felt (white) 2 pieces

tail foundation
felt (ecru) 2 pieces

13 Wobbuffet

Difficulty ▬▬▬▬▭▭
p. 14

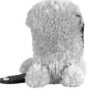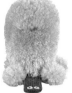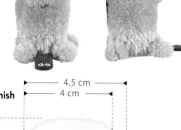

SUPPLIES (Numbers in parentheses are Hamanaka yarn color codes.)

Yarn: Piccolo light blue (12)
Felt: light blue, red and dark gray (small piece of each)
Fabric: cotton broadcloth in soft pink and white (small piece of each)
Thread: white (small amount)

Tools
Pompom maker (3.5 cm, 5.5 cm), 4 binder clips, scissors, handicraft glue, permanent marker (black superfine point), toothpick

How to Make *See pp. 40–45.
1. Make a single-color pompom for the body.
2. Trim the bottom.
3. Use the templates to make the different parts.
4. Glue a tail between the body and the base.
5. Make four small pompoms for the legs and attach.
6. Attach the rest of the parts.

How to Finish

0.9 cm
1.5 cm
4 cm — eye
mouth
leg
6.3 cm

4.5 cm
4 cm
body
tail
5.5 cm

★ Mouth: Trim the yarn about 2 mm to form an indentation for where the mouth will go before attaching it.
◄— 5 cm —►

base

Insert and glue the tail between the body and the base.

How to Wrap the Yarn

Body double-strand wrap
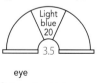
① light blue 170
5.5
② light blue 170

Legs double-strand wrap (make 4)

Light blue 20
3.5

How to Trim

Front
Side
▨ = sections to be trimmed away

4 cm
6.3 cm
◄—3.5 cm—►

4.5 cm
4 cm
4 cm
◄—3.5 cm—►

Parts

leg
❶ Make small pompoms.
*See p. 56.

knot

❷ Trim into a half sphere.
◄— 1.8 cm —►
1.3 cm
1.8 cm

❸ Make four in the same way.
(seen from above)

eye
❶ Draw a line with the permanent marker.

❷ Spread glue on the piece and fold it.

❸ Make one more.
*See p. 45 (mouth).

mouth
tongue
Glue together.

tail

Draw the dots in the center with the permanent marker.
Glue designs onto the tail.
Glue both tail pieces together.
Draw a line using the permanent marker.

Templates (actual size)

base
felt (light blue) 1 piece

○ design for tail
fabric (white) 2 pieces

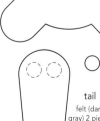

tongue
fabric (soft pink) 1 piece

mouth
felt (red) 1 piece

tail
felt (dark gray) 2 pieces

eye
felt (light blue) 2 pieces

Insert this part between the body and the base.

14 Eevee

Difficulty ▬▬▬▬▭▭▭▭▭
pp. 16, 24

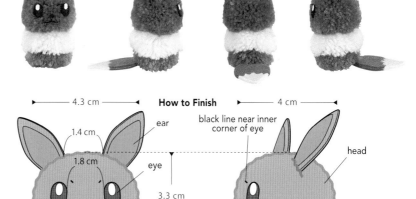

SUPPLIES (Numbers in parentheses are Hamanaka yarn color codes.)

Yarn: Piccolo ⬤ brown (21), cream (41), (nose) ⬤ black (20)

Tino (lines near inner corner of eyes) ⬤ black (15)

Felt: brown, black and cream (small piece of each)

Fabric: cotton broadcloth in cream and white (small piece of each)

Tools

Pompom maker (3.5 cm), 4 binder clips, scissors, handicraft glue, wool needle, permanent marker (black superfine point), toothpick

How to Make *See pp. 40–45.

1. Make a solid-color pompom for the head.
2. Make a two-color pompom for the body.
3. Attach the two and trim the bottom.
4. Use the templates to make the different parts.
5. Attach the parts.

Tips

◎ In order to emphasize the fullness of the fur around the chest, we cut the yarn to different lengths. Take a good look at how the yarn is cut.

How to Finish

4.3 cm — ear — 4 cm

1.4 cm — black line near inner corner of eye — head

1.8 cm — eye

3.3 cm — nose — mouth

3.2 cm — body — tail

4 cm — 4 cm

★ Eyes: Trim the yarn about 2 mm to form an indentation for where they will go before attaching them.

Parts

tail

tip of tail

base of tail

tail foundation

base of tail

tip of tail

For the black lines near the inner corner of the eyes, use black Tino yarn. *See p. 44 (nose).

For the nose, use black Piccolo yarn. *See p. 44.

❶ Spread glue over the entire foundation of the tail and glue together.

❷ Do the same with the underside of the tail.

eye *See p. 44.

highlight for the eye

pupil

Glue together.

mouth *See p. 45.

ear *See p. 57.

How to Trim

Trim the brown yarn about 3 mm shorter than the cream yarn.

3 mm — body

How to Wrap the Yarn

Head double-strand wrap

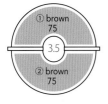

① brown 75
3.5
② brown 75

Body double-strand wrap

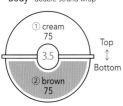

① cream 75
3.5
② brown 75

Top ↕ Bottom

Templates (actual size)

Template for Mouth (actual size)

outer ear
felt (brown) 2 pieces

inner ear
felt (black) 2 pieces

Insert this part into the head.

base of tail
felt (brown) 2 pieces

tail foundation
fabric (cream) 1 piece

Insert this part into the body.

tip of tail
felt (cream) 2 pieces

highlight for the eye
fabric (white) 2 pieces

pupil
fabric (black) 2 pieces

mouth
felt (brown) 1 piece

mouth line

15 Torchic

Difficulty ▰▰▰▱▱▱▱▱▱
pp. 16, 30

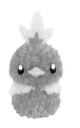 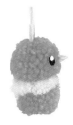 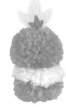 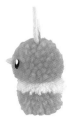

SUPPLIES (Numbers in parentheses are Hamanaka yarn color codes.)

Yarn: Bonny ● orange (434)
Piccolo yellow (8)
Felt: brown, yellow and black (small piece of each)
Fabric: cotton broadcloth in orange and white
(small piece of each)

Tools
Pompom maker (3.5 cm), 4 binder clips, scissors,
handicraft glue, wool needle, toothpick

How to Make *See pp. 40–45.
1. Make a solid-color pompom for the head.
2. Make a two-color pompom for the body.
3. Attach the two and trim the bottom.
4. Use the templates to make the different parts.
5. Attach the parts.

Tips
◎ When connecting the two pompoms, pay careful
attention to the position of the yellow yarn.

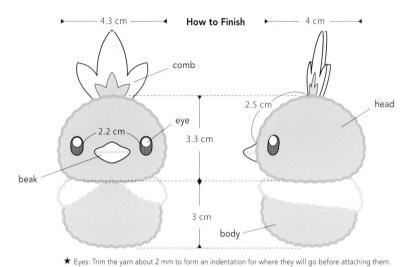

How to Finish

comb

eye

beak

2.2 cm

3.3 cm

3 cm

4.3 cm

4 cm

2.5 cm

head

body

4 cm

4 cm

★ Eyes: Trim the yarn about 2 mm to form an indentation for where they will go before attaching them.

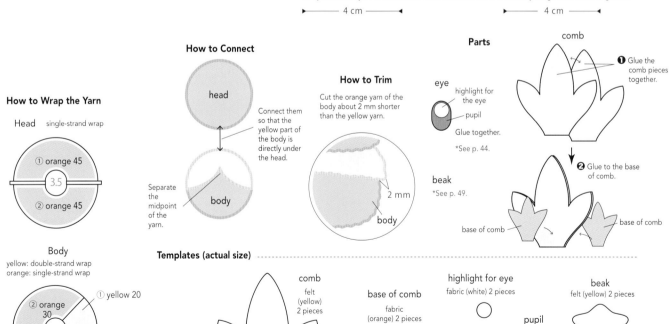

How to Wrap the Yarn

Head single-strand wrap

① orange 45
② orange 45
3.5

Body
yellow: double-strand wrap
orange: single-strand wrap

② orange 30
③ orange 30
3.5
① yellow 20
④ yellow 20
Bottom ↔ Top

How to Connect

head

body

Connect them
so that the
yellow part of
the body is
directly under
the head.

Separate
the
midpoint
of the
yarn.

How to Trim

Cut the orange yarn of the
body about 2 mm shorter
than the yellow yarn.

2 mm

body

Parts

eye
highlight for
the eye
pupil
Glue together.
*See p. 44.

beak
*See p. 49.

comb

❶ Glue the
comb pieces
together.

❷ Glue to the base
of comb.

base of comb base of comb

Templates (actual size)

comb
felt (yellow)
2 pieces

Insert this part into
the head.

base of comb
fabric
(orange) 2 pieces

highlight for eye
fabric (white) 2 pieces

pupil
felt (black)
2 pieces

beak
felt (yellow) 2 pieces

front of beak

16 Jirachi

Difficulty ▰▰▰▱▱▱▱

p. 17

SUPPLIES (Numbers in parentheses are Hamanaka yarn color codes.)

Yarn: Lovely Baby ● light gray (27)
 Four Ply light yellow (323)
 Piccolo (body design) ● black (20)
Felt: yellow (10 x 6 cm), light green, black and light gray (small piece of each)
Fabric: cotton broadcloth in white and chartreuse (small piece of each)
Thread: white (small amount)

Tools

Pompom maker (3.5 cm), 4 binder clips, scissors, handicraft glue, wool needle, permanent marker (black superfine point), toothpick

How to Make *See pp. 40–45.

1. Make a patterned pompom for the head.
2. Make a solid-color pompom for the body.
3. Attach the two and trim the bottom.
4. Make three small pompoms and attach.
5. Use the templates to make the different parts.
6. Attach the parts.

How to Finish

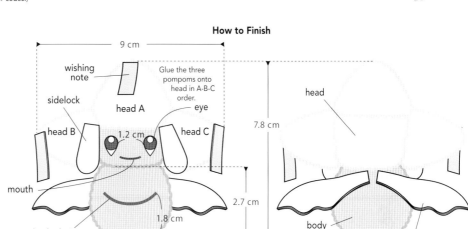

9 cm

wishing note

sidelock

head A

eye

head B

head C

1.2 cm

mouth

body design

1.8 cm

2.7 cm

7.8 cm

head

body

ruffles on back

★ Eyes: Trim the yarn about 2 mm to form an indentation for where they will go before attaching them.

◀ 3.5 cm ▶

How to Wrap the Yarn

Head double-strand wrap

① light gray 20 ② light yellow 80

3.5

Front ↕ Back

③ light yellow 110

Body double-strand wrap

① light gray 60

3.5

② light gray 60

Heads A, B, C
double-strand wrap (make 3)

light yellow 45

3.5

How to Trim

= sections to be trimmed away

head

3 cm

1.8 cm

4 cm

head A, B, C

❶ Make small pompoms.
*See p. 56.

2.5 cm

❷ Trim pompom into a cone shape.

3 cm

❸ Make all three in the same way.

Parts

eye

highlight for the eye
pupil
iris

Glue together.
*See p. 44.

ruffles for back

Glue together.

body design
Cover black yarn in glue and attach.

mouth

❶ Draw a line with the permanent marker.

❷ Apply glue to entire length and carefully create the shape before the glue dries.

*See p. 45.

Templates (actual size)

sidelocks
felt (yellow) 2 pieces

ruffles for back
felt (yellow) 4 pieces

Attach this part to the body.

eye
felt (black) 2 pieces

highlight for the eye
fabric (white) 2 pieces

mark below eye
fabric (chartreuse) 2 pieces

wishing note
felt (light green) 3 pieces

mouth
felt (light gray) 1 piece

Templates (actual size)
mouth

body design

17 Pachirisu

Difficulty

pp. 18, 32

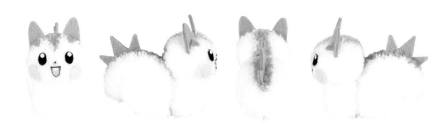

SUPPLIES (Numbers in parentheses are Hamanaka yarn color codes.)

Yarn: Piccolo ○ white (1), light blue (12)
Tino (nose) ● black (15)
Felt: light blue (8 x 6 cm), yellow, black and pink (small piece of each)
Fabric: cotton broadcloth in white (small piece)

Tools

Pompom maker (3.5 cm, 5.5 cm), 4 binder clips, scissors, handicraft glue, wool needle, permanent marker (black superfine point), toothpick

How to Make *See pp. 40–45.

1. Make a solid-color pompom for the body.
2. Make patterned pompoms for the head and tail.
3. Attach the head and body and trim the bottom.
4. Attach the tail to the body.
5. Use the templates to make the different parts.
6. Attach the parts.

How to Finish

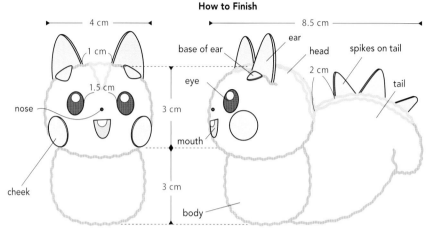

4 cm

1 cm

1.5 cm

nose

cheek

3.5 cm

eye

base of ear

ear

head

spikes on tail

2 cm

tail

mouth

body

8.5 cm

3 cm

3 cm

3 cm

★ Eyes, cheeks, mouth: Trim the yarn about 2 mm to form an indentation for where they will go before attaching them.

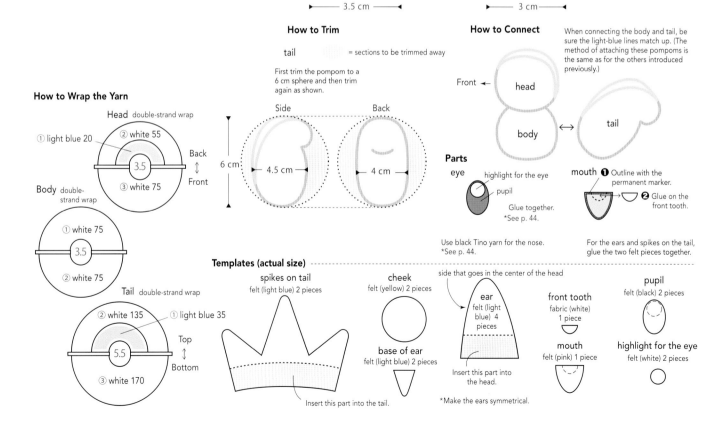

How to Wrap the Yarn

Head double-strand wrap
① light blue 20
② white 55
3.5
③ white 75
Back ↕ Front

Body double-strand wrap
① white 75
3.5
② white 75

Tail double-strand wrap
② white 135
① light blue 35
5.5
Top ↕ Bottom
③ white 170

How to Trim

tail [] = sections to be trimmed away

First trim the pompom to a 6 cm sphere and then trim again as shown.

Side Back
6 cm
4.5 cm 4 cm

How to Connect

When connecting the body and tail, be sure the light-blue lines match up. (The method of attaching these pompoms is the same as for the others introduced previously.)

Front ← head
body ↔ tail

Parts

eye
highlight for the eye
pupil
Glue together.
*See p. 44.

Use black Tino yarn for the nose. *See p. 44.

mouth ❶ Outline with the permanent marker.
❷ Glue on the front tooth.

For the ears and spikes on the tail, glue the two felt pieces together.

Templates (actual size)

spikes on tail
felt (light blue) 2 pieces
Insert this part into the tail.

cheek
felt (yellow) 2 pieces

base of ear
felt (light blue) 2 pieces

side that goes in the center of the head
ear
felt (light blue) 4 pieces
Insert this part into the head.
*Make the ears symmetrical.

front tooth
fabric (white) 1 piece

mouth
felt (pink) 1 piece

pupil
felt (black) 2 pieces

highlight for the eye
felt (white) 2 pieces

19 Buneary

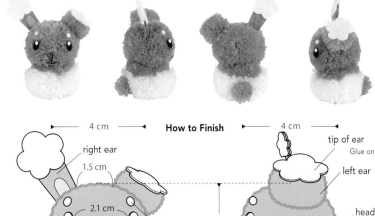

Difficulty ●━━━━━━○○○
pp. 18, 25

SUPPLIES (Numbers in parentheses are Hamanaka yarn color codes.)

Yarn: Piccolo ● light brown (28), ● cream (41),
(nose) ● dark pink (5)
Felt: lemon yellow, black and light brown (small piece of each)
Fabric: cotton broadcloth in pink and white (small piece of each)
Thread: white (small amount)

Tools
Pompom maker (3.5 cm), 4 binder clips, scissors, handicraft glue, wool needle, permanent marker (black superfine point), toothpick

How to Make *See pp. 40–45.
1. Make a solid-color pompom for the head.
2. Make a two-color pompom for the body.
3. Attach the two and trim the bottom.
4. Make two small pompoms and attach.
5. Use the templates to make the different parts.
6. Attach the parts.

How to Finish

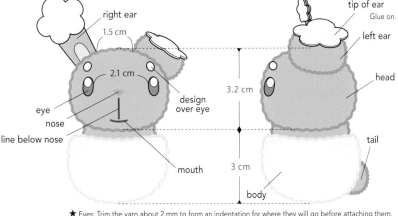

right ear
1.5 cm
4 cm
2.1 cm
eye
nose
line below nose
mouth
design over eye
3.2 cm
tip of ear
Glue on.
left ear
head
tail
body
3 cm
4 cm
4.5 cm
4.5 cm

★ Eyes: Trim the yarn about 2 mm to form an indentation for where they will go before attaching them.

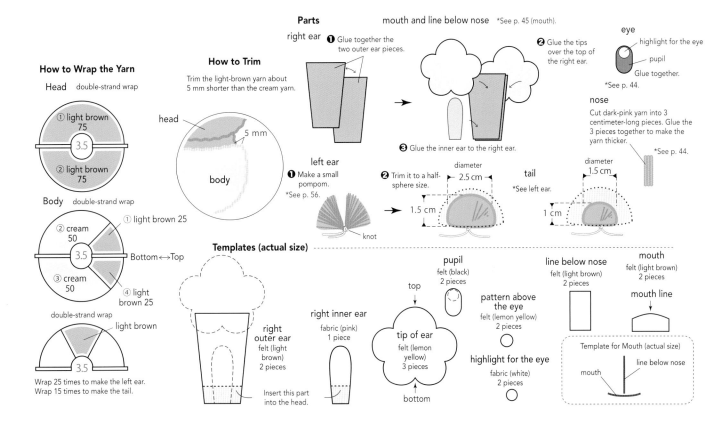

How to Wrap the Yarn

Head double-strand wrap
① light brown 75
② light brown 75
3.5

Body double-strand wrap
② cream 50
① light brown 25
Bottom↔Top
③ cream 50
④ light brown 25
3.5

double-strand wrap
light brown
3.5
Wrap 25 times to make the left ear.
Wrap 15 times to make the tail.

How to Trim
Trim the light-brown yarn about 5 mm shorter than the cream yarn.
head
5 mm
body

Parts

right ear
❶ Glue together the two outer ear pieces.
❸ Glue the inner ear to the right ear.

left ear
❶ Make a small pompom. *See p. 56.
❷ Trim it to a half-sphere size.
diameter 2.5 cm
1.5 cm
knot

mouth and line below nose *See p. 45 (mouth).
❷ Glue the tips over the top of the right ear.

tail *See left ear.
diameter 1.5 cm
1 cm

eye
highlight for the eye
pupil
Glue together.
*See p. 44.

nose
Cut dark-pink yarn into 3 centimeter-long pieces. Glue the 3 pieces together to make the yarn thicker.
*See p. 44.

Templates (actual size)

right outer ear
felt (light brown)
2 pieces
Insert this part into the head.

right inner ear
fabric (pink)
1 piece

pupil
felt (black)
2 pieces

top
tip of ear
felt (lemon yellow)
3 pieces
bottom

pattern above the eye
felt (lemon yellow)
2 pieces

highlight for the eye
fabric (white)
2 pieces

line below nose
felt (light brown)
2 pieces

mouth
felt (light brown)
2 pieces

mouth line

Template for Mouth (actual size)
line below nose
mouth

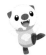

20 Oshawott

Difficulty ▬▬▬▬▬▬▬▬▬
pp. 19, 28

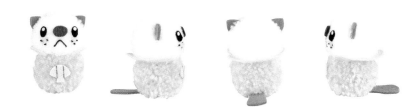

SUPPLIES (Numbers in parentheses are Hamanaka yarn color codes.)

Yarn: Dorina mint green (55)
 Piccolo ○ white (1)
 Tino (facial hair) ● black (15)
Felt: mint green (6 x 5 cm), blue (8 x 4 cm), dark brown, white, cream and black (small piece of each)
Fabric: cotton broadcloth in white (small piece)

Tools
Pompom maker (3.5 cm), 4 binder clips, scissors, handicraft glue, wool needle, permanent marker (black superfine point), toothpick

How to Make *See pp. 40–45.
1. Make solid-color pompoms for the head and body.
2. Attach the two and trim the bottom.
3. Use the templates to make the different parts.
4. Attach the parts.

Tips
◎ Adjust the size of the pompoms so that there is a 2 cm gap in the front in between the ends of the collar.

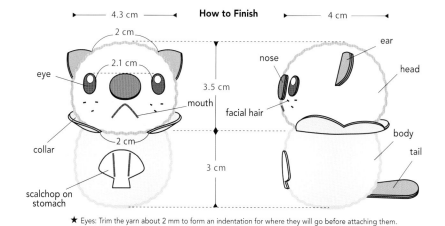

How to Finish

4.3 cm · 2 cm · 2.1 cm · 3.5 cm · 2 cm · 3 cm · 4 cm

eye · mouth · collar · scalchop on stomach

4 cm · nose · ear · head · facial hair · body · tail · 4 cm

★ Eyes: Trim the yarn about 2 mm to form an indentation for where they will go before attaching them.

Parts

scalchop on stomach
Draw two lines on the scalchop using the permanent marker.

eye
highlight for the eye
pupil
*See p. 44.

*See p. 45 (Mouth).

Use black Tino yarn for the facial hair.
*See p. 44 (nose).

For the nose, ear and tail, glue the two pieces together and double up the parts.

collar
inside
outside

❶ In order to make it sturdier, cover the underside of the collar with glue and let it dry.

❷ Spread glue around the part of the collar that attaches to the neck.

How to Wrap the Yarn

Head double-strand wrap
① white 75
3.5
② white 75

Template for Mouth (actual size)

Body single-strand wrap
① mint green 40
3.5
② mint green 40

★ Dorina (mint green) is a thick, firm yarn. After making the pompom, use a toothpick to unravel the yarn.

Templates (actual size)

nose
felt (dark brown) 2 pieces

ear
felt (blue) 4 pieces
Insert this part into the head.

tail
felt (blue) 2 pieces
Insert this part into the body.

scalchop on stomach
felt (cream) 1 piece

mouth
felt (white) 1 piece

mouth line

highlight for the eye
fabric (white) 2 pieces

pupil
felt (black) 2 pieces

collar
felt (mint green) 1 piece
Glue this part onto the neck.
front

21 Emolga

Difficulty
pp. 19, 32

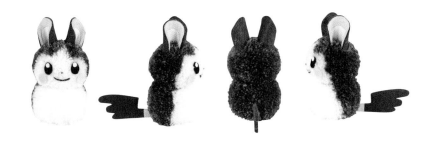

SUPPLIES (Numbers in parentheses are Hamanaka yarn color codes.)
Yarn: Four Ply ● dark gray (370), ○ white (301)
Tino (nose) ● black (15)
Felt: dark gray, black, yellow and white
(small piece of each)
Fabric: cotton broadcloth in white and yellow
(small piece of each)

Tools
Pompom maker (3.5 cm), 4 binder clips, scissors,
handicraft glue, wool needle, permanent marker
(black superfine point), toothpick, masking tape

How to Make *See pp. 40–45.
1. Make a patterned pompom for the head.
2. Make a two-color pompom for the body.
3. Attach the two and trim the bottom.
4. Use the templates to make the different parts.
5. Attach the parts.

Tips
◎ Neaten the hairline "W" with a toothpick.

How to Finish

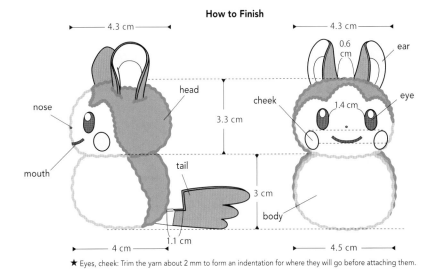

★ Eyes, cheek: Trim the yarn about 2 mm to form an indentation for where they will go before attaching them.

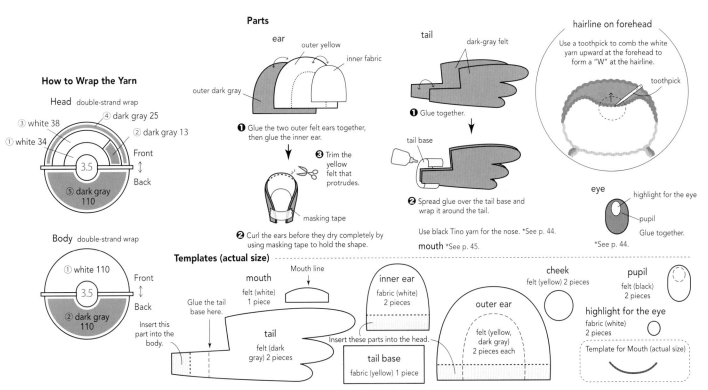

22 Dedenne

Difficulty ▭▭▭▭▭▭
pp. 20, 32

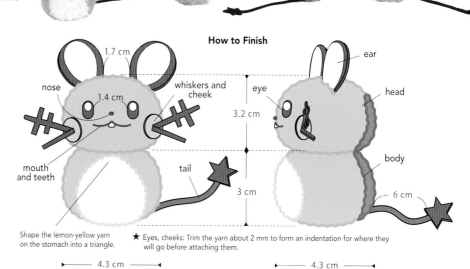

SUPPLIES (Numbers in parentheses are Hamanaka yarn color codes.)

Yarn: Piccolo ⬤ ocher (27), ⬤ black (20)
 Four Ply lemon yellow (308)
 Tino (nose) ⬤ black (15)
Felt: black, lemon yellow, orange, white and
ocher (small piece of each)
Fabric: cotton broadcloth in white and black
(small piece of each)
String: black cotton (7 cm long)

Tools

Pompom maker (3.5 cm), 4 binder clips, scissors,
handicraft glue, wool needle, permanent marker
(black superfine point), toothpick, tweezers

How to Make *See pp. 40–45.

1. Make patterned pompoms for the head and
 body.
2. Attach the two and trim the bottom.
3. Use the templates to make the different parts.
4. Attach the parts.

Tips

◎ The whiskers are very complicated, so be sure
to read the instructions carefully. Do your best to
arrange the stomach into a triangle shape.

How to Finish

nose — 1.4 cm
1.7 cm
whiskers and cheek
mouth and teeth
tail
ear
eye
3.2 cm
head
body
3 cm
6 cm

Shape the lemon-yellow yarn on the stomach into a triangle.

★ Eyes, cheeks: Trim the yarn about 2 mm to form an indentation for where they will go before attaching them.

4.3 cm 4.3 cm

How to Wrap the Yarn

Head double-strand wrap

② ocher 63
① black 12
3.5
③ ocher 75
Back
Front
Back

Body double-strand wrap

② ocher 63
① black 12
3.5
Back
Front
④ ocher 20
⑤ ocher 35
③ lemon yellow 40

How to Connect

Back
head
Attach so that the black stripe becomes a continuous line.
body

Parts

whiskers and cheek

❶ As in the case of Meowth's whiskers (p. 59), coat the sheet with glue and cut the whiskers out when it's dry.

❷ Glue long and short cross whiskers onto long whisker.
5mm
3mm
long felt cross whisker
short felt cross whisker
long felt whisker

❸ For added strength, glue fabric whiskers onto the back. Tweezers will make the job easier.
long fabric cross whisker
short fabric cross whisker

❹ Punch holes into the cheek pieces and insert long and short whiskers through them.
cheek

❺ Spread glue on the back of the cheeks and the whisker bottoms, then attach to the face.

tail
❶ Attach a piece of colored string to a tail end.
tip of tail
❷ Glue and cover the end of the string with another tail end.
*See p. 44.
black string

eye
highlight for the eye
pupil
Glue together.
*See p. 44.

mouth and tooth
Glue the tooth on after gluing on the mouth.

ear *See p. 57
Use black Tino yarn for the nose.
*See p. 44.

Templates (actual size)

outer ear
felt (black) 2 pieces

Insert this part into the head.

inner ear
felt (lemon yellow)
2 pieces

long whisker
felt (black)
2 pieces

short whisker
felt (black)
2 pieces

cheek
felt (orange)
2 pieces

tooth
felt (white) 1 piece

highlight for the eye
fabric (white) 2 pieces

pupil
felt (black) 2 pieces

long cross whisker
felt, fabric (black) 2 pieces each

short cross whisker
felt, fabric (black) 2 pieces each

mouth
felt (ocher) 1 piece
mouth line

tip of tail
felt (black) 2 pieces

Template for Mouth (actual size)

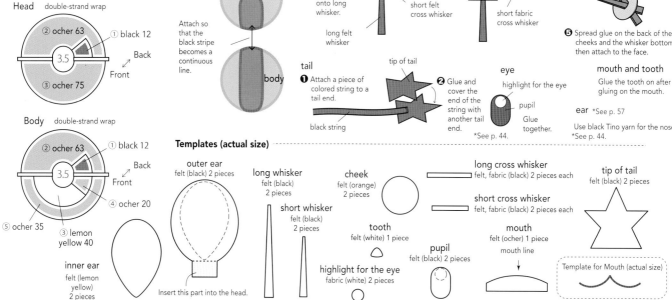

23 Greninja

Difficulty ⬤▬▬▬▬▬▬
pp. 21, 28

SUPPLIES (Numbers in parentheses are Hamanaka yarn color codes.)
Yarn: Tino ⬤ blue (17), ⬤ pink (4), ◯ ecru (2),
◯ white (1)
Felt: blue (9 x 9 cm), ecru (8 x 5 cm), light blue (7 x 6 cm),
pink (7 x 4 cm) and white (small piece)
Fabric: cotton broadcloth in pink and white (small piece
of each)

Tools
Pompom maker (3.5 cm), 4 binder clips, scissors,
handicraft glue, wool needle, toothpick

How to Make *See pp. 40–45.
1. Make patterned pompoms for the head and body.
2. Attach the two and trim the bottom.
3. Use the templates to make the different parts.
4. Attach the parts.

Tips
◎ When trimming the head, shaping the nose into
a point will make it look even cooler.

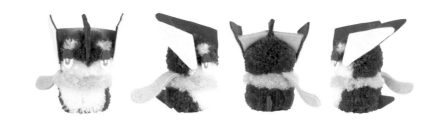

How to Finish

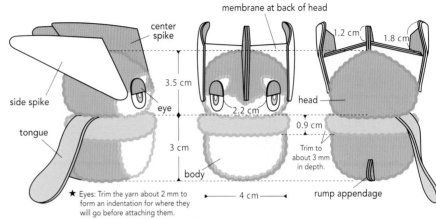

★ Eyes: Trim the yarn about 2 mm to form an indentation for where they will go before attaching them.

center spike, membrane at back of head, side spike, eye, tongue, head, body, rump appendage

3.5 cm, 3 cm, 2.2 cm, 0.9 cm, 4 cm, 1.2 cm, 1.8 cm, Trim to about 3 mm in depth.

How to Wrap the Yarn

Head double-strand wrap
④ blue 75 ③ white 10
① blue 80 ② blue 15
3.5
⑤ blue 85 ⑥ ecru 85
Top, Back ↔ Front, Bottom

Body double-strand wrap
② blue 115 ① pink 60
3.5
③ blue 45 ④ ecru 70 ⑤ pink 60
Back, Bottom ↔ Top, Front

How to Connect
head
↕
body

Parts
eye
highlight for the eye
eyelid
white of the eye
pupil

With white of the eye as the base, glue on pupil and highlight.
*See p. 44.

spike

❸ Glue together the 2 side spikes and attach to the 2 membranes.
❷ Glue together the 2 membranes and attach to the center spike and head.
1.8 cm
1.2 cm
❶ Glue together the 2 center spikes and attach.
head
top

pattern on the head
Pull and fluff the white yarn sections with a toothpick.
Pull and shape the blue yarn.
Glue together the two pieces of tongue, then glue together the two pieces of the rump appendage.

Templates (actual size)

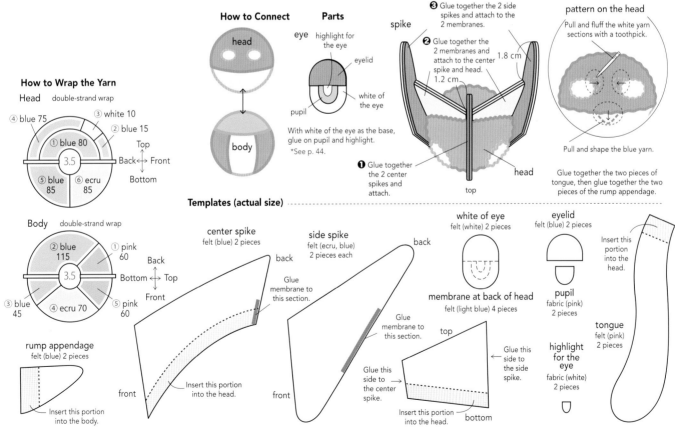

rump appendage
felt (blue) 2 pieces
Insert this portion into the body.

center spike
felt (blue) 2 pieces
back
Glue membrane to this section.
Insert this portion into the head.
front

side spike
felt (ecru, blue) 2 pieces each
back
Glue membrane to this section.
Glue this side to the center spike.
front

top
Glue this side to the side spike.
Insert this portion into the head.
bottom

white of eye
felt (white) 2 pieces

membrane at back of head
felt (light blue) 4 pieces

eyelid
felt (blue) 2 pieces

pupil
fabric (pink) 2 pieces

highlight for the eye
fabric (white) 2 pieces

tongue
felt (pink) 2 pieces
Insert this portion into the head.

24 Rowlet

Difficulty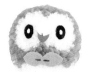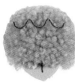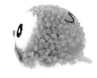

Difficulty ▰▰▰▰▰▱▱▱▱
pp. 22, 26

SUPPLIES (Numbers in parentheses are Hamanaka yarn color codes.)

Yarn: Bonny ● light brown (418)
　　　Piccolo ○ white (1)
　　　Tino (comb on back of head) ● dark brown (14)
Felt: light green (7 x 5 cm), black and white (small piece of each)
Fabric: cotton broadcloth in light orange and white (small piece of each)

Tools

Pompom maker (5.5 cm), 4 binder clips, scissors, handicraft glue, wool needle, permanent marker (black superfine point), toothpick

How to Make *See pp. 40–45.
1. Make a patterned pompom for the body.
2. Trim the bottom.
3. Use the templates to make the different parts.
4. Attach the parts.

Tips

◎ Make sure the bottom is cut evenly so that the eyes look straight ahead.

How to Finish

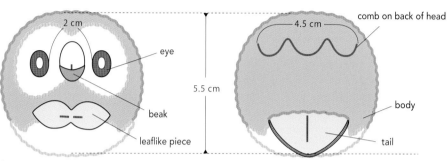

★ Eyes: Trim the yarn about 2 mm to form an indentation for where they will go before attaching them.

Parts

eye

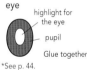

highlight for the eye

pupil

Glue together.

*See p. 44.

beak

❶ Apply glue along the straight ends and attach.

beak

Align and glue the beak to the face.

❷ Use a permanent marker to draw the line.

❸ Glue on the base of the beak.

leaflike piece

Use a permanent marker to draw the lines.

shaping the face

Use a toothpick to fluff up the light-brown yarn and pull into the white area.

comb on back of head

❶ Apply glue to the yarn (dark brown) and shape it before the glue dries completely.
　*Refer to the template.
　*See p. 44 (nose).

❷ After glue dries, reapply and attach to body.

How to Wrap the Yarn

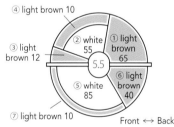

Body　Light brown is a single-strand wrap, white is a double-strand wrap.

④ light brown 10
③ light brown 12
② white 55
① light brown 65
⑤ white 85
⑥ light brown 40
⑦ light brown 10

Front ⟷ Back

tail

❷ Use a permanent marker to draw the line.

❶ Glue the parts together.

Templates (actual size)

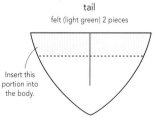

leaflike piece
felt (light green) 1 piece

base of the beak
fabric (light orange) 1 piece

beak
felt (white) 1 piece

tail
felt (light green) 2 pieces

Insert this portion into the body.

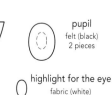

pupil
felt (black) 2 pieces

highlight for the eye
fabric (white) 2 pieces

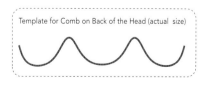

Template for Comb on Back of the Head (actual size)

25 Litten

Difficulty ▬▬▬▬▬▬▬▬▬▬
pp. 22, 30

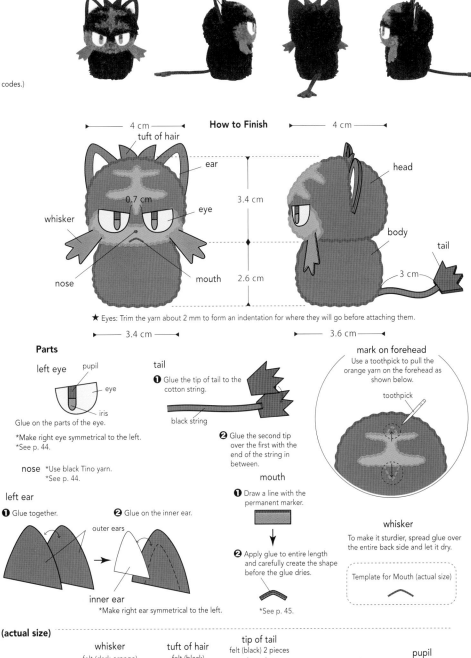

SUPPLIES (Numbers in parentheses are Hamanaka yarn color codes.)
Yarn: Tino ● black (15), ● dark orange (7)
(nose) ● black (15)
Felt: black (8 x 5 cm), dark orange and yellow
(small piece of each)
Fabric: cotton broadcloth in white, black and
dark orange (small piece of each)
String: black cotton (4 cm long)

Tools
Pompom maker (3.5 cm), 4 binder clips, scissors,
handicraft glue, wool needle, permanent marker
(black superfine point), toothpick

How to Make *See pp. 40–45.
1. Make a patterned pompom for the head.
2. Make a solid-color pompom for the body.
3. Attach the two and trim the bottom.
4. Use the templates to make the different parts.
5. Attach the parts.

Tips
◎ If you wrap the first, second and third levels
correctly, the shape of the forehead will be
perfect.

How to Finish

4 cm ◄───► 4 cm

tuft of hair
ear
0.7 cm
whisker — eye
nose — mouth
3.4 cm

head
body
tail
3 cm
2.6 cm

3.4 cm ◄───► 3.6 cm

★ Eyes: Trim the yarn about 2 mm to form an indentation for where they will go before attaching them.

mark on forehead
Use a toothpick to pull the
orange yarn on the forehead as
shown below.
toothpick

Parts

left eye
pupil
eye
iris
Glue on the parts of the eye.
*Make right eye symmetrical to the left.
*See p. 44.

nose *Use black Tino yarn.
*See p. 44.

left ear
❶ Glue together.
outer ears
❷ Glue on the inner ear.
inner ear
*Make right ear symmetrical to the left.

tail
❶ Glue the tip of tail to the
cotton string.
black string
❷ Glue the second tip
over the first with the
end of the string in
between.

mouth
❶ Draw a line with the
permanent marker.
❷ Apply glue to entire length
and carefully create the shape
before the glue dries.
*See p. 45.

whisker
To make it sturdier, spread glue over
the entire back side and let it dry.
Template for Mouth (actual size)

How to Wrap the Yarn
Head double-strand wrap
*O=dark orange
⑪ black
⑨ black 8
70
⑧ O 5
③ black 7
⑦ black 8
⑫ O 30
⑥ O 3
⑩ O 12
② O 12
④ O 10
⑤ black 5
① black 5
3.5
Front ↕ Back
⑬ black 175

Body double-strand wrap
① black 175
edge that faces center of the head
3.5
② black 175

Templates (actual size)

outer ear
felt (black) 4 pieces
edge that faces center of the head
Insert this portion into the head.

inner ear
fabric (white) 2 pieces
edge that faces center of the head
Insert this portion into the head.

whisker
felt (dark orange)
2 pieces
Insert this portion into the body.

tuft of hair
felt (black)
1 piece
Insert this portion into the head.

tip of tail
felt (black) 2 pieces

mouth
felt (dark orange)
1 piece

eye
felt (yellow)
2 pieces

pupil
fabric (black) 2 pieces

iris
fabric (dark orange) 2 pieces

*Inner and outer ears, eyes and pupils should be cut symmetrically.

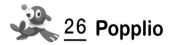

26 Popplio

Difficulty ▬▬▬▬▬▭▭▭

pp. 22, 29

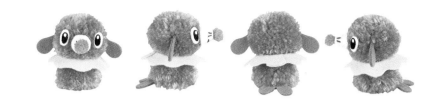

SUPPLIES (Numbers in parentheses are Hamanaka yarn color codes.)

Yarn: Piccolo ○ blue (23)
 Tino (nose) ○ pink (5)
Felt: light blue (13 x 7 cm), blue (10 x 4 cm) and white (small piece)
Fabric: cotton broadcloth in white and black (small piece of each)

Tools
Pompom maker (3.5 cm), 4 binder clips, scissors, handicraft glue, wool needle, permanent marker (black superfine point), toothpick

How to Make *See pp. 40–45.
1. Make solid-color pompoms for the head and body.
2. Attach the two and trim the bottom.
3. Use the templates to make the different parts.
4. Attach the parts.

Tips
◎ Cut the body slightly smaller than the head in the shape of a trapezoid.

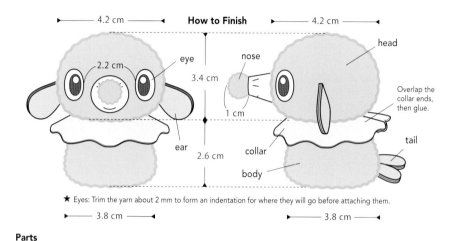

How to Finish

← 4.2 cm → ← 4.2 cm →

eye · 2.2 cm · 3.4 cm · nose · head

ear · 2.6 cm · 1 cm · collar · body · Overlap the collar ends, then glue. · tail

← 3.8 cm → ← 3.8 cm →

★ Eyes: Trim the yarn about 2 mm to form an indentation for where they will go before attaching them.

Parts

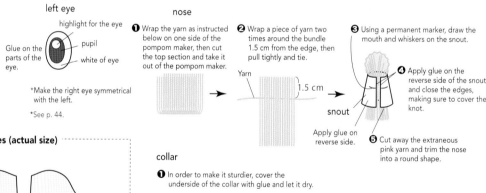

left eye

highlight for the eye
pupil
white of eye

Glue on the parts of the eye.

*Make the right eye symmetrical with the left.
*See p. 44.

nose

❶ Wrap the yarn as instructed below on one side of the pompom maker, then cut the top section and take it out of the pompom maker.

❷ Wrap a piece of yarn two times around the bundle 1.5 cm from the edge, then pull tightly and tie.

Yarn — 1.5 cm

snout

Apply glue on reverse side.

❸ Using a permanent marker, draw the mouth and whiskers on the snout.

❹ Apply glue on the reverse side of the snout and close the edges, making sure to cover the knot.

❺ Cut away the extraneous pink yarn and trim the nose into a round shape.

collar

❶ In order to make it sturdier, cover the underside of the collar with glue and let it dry.

❷ Apply glue to the section that overlaps, place around the neck and adhere.

ear, tail fin
Glue the ears and tail fin to the body.

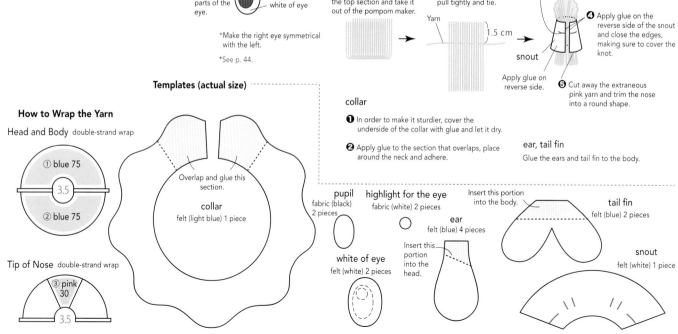

Templates (actual size)

How to Wrap the Yarn

Head and Body double-strand wrap

① blue 75
3.5
② blue 75

Tip of Nose double-strand wrap

③ pink 30
3.5

collar
felt (light blue) 1 piece
Overlap and glue this section.

pupil
fabric (black) 2 pieces

white of eye
felt (white) 2 pieces

highlight for the eye
fabric (white) 2 pieces

ear
felt (blue) 4 pieces
Insert this portion into the head.

Insert this portion into the body.

tail fin
felt (blue) 2 pieces

snout
felt (white) 1 piece

27 Minccino

Difficulty �altech

p. 25

SUPPLIES (Numbers in parentheses are Hamanaka yarn color codes.)

Yarn: Piccolo ⬛ gray (33)
 Tino (nose) ● black (15)
Felt: gray (18 x 7 cm), white (5 x 5 cm) and dark brown (small piece)
Fabric: cotton broadcloth in white (9 x 7 cm) and pink (small piece)

Tools
Pompom maker (3.5 cm), 4 binder clips, scissors, handicraft glue, wool needle, permanent marker (black superfine point), toothpick

How to Make *See pp. 40–45.
1. Make solid-color pompoms for the head and body.
2. Attach the two and trim the bottom.
3. Use the templates to make the different parts.
4. Attach the parts.

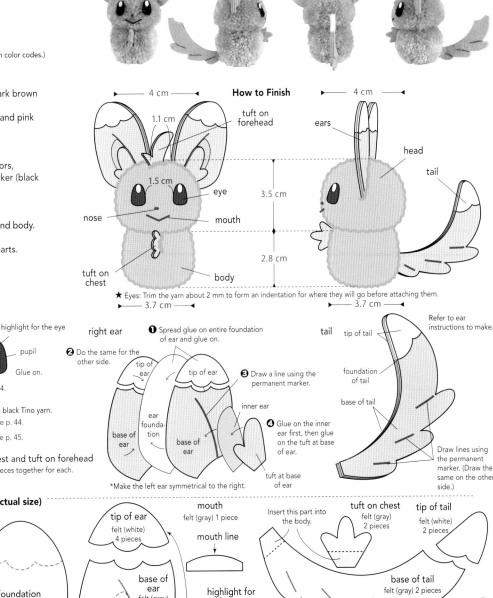

How to Finish

★ Eyes: Trim the yarn about 2 mm to form an indentation for where they will go before attaching them.

Parts

eye — highlight for the eye
 pupil
 Glue on.
 *See p. 44.

nose — Use black Tino yarn.
 *See p. 44.

mouth — *See p. 45.

tuft on chest and tuft on forehead
Glue the 2 pieces together for each.

★ See p. 74 for diagram on how to wrap the yarn.

Template for Mouth (actual size)

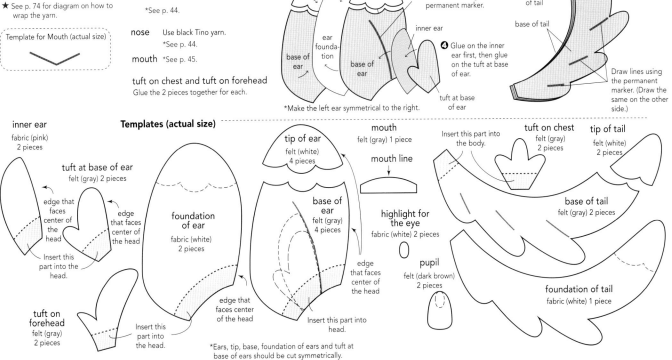

Templates (actual size)

*Ears, tip, base, foundation of ears and tuft at base of ears should be cut symmetrically.

28 Chikorita

Difficulty ▮▮▮▮▮▮▮▮▮▮▮▮▮▮▮▮▮
p. 26

SUPPLIES (Numbers in parentheses are Hamanaka yarn color codes.)

Yarn: Bonny　pale yellow green (407)
Felt: Green (7 x 5 cm), white and yellow green (small piece of each)
Fabric: cotton broadcloth in red, pink and white (small piece of each)

Tools
Pompom maker (5.5 cm), 4 binder clips, scissors, handicraft glue, permanent marker (black superfine point), toothpick, tweezers

How to Make *See pp. 40–45.
1. Make a solid-color pompom.
2. Trim the bottom.
3. Use the templates to make the different parts.
4. Attach the parts.

Tips
◎ Since there are many small pieces such as the eyes and parts around the neck, tweezers will come in handy.

How to Finish

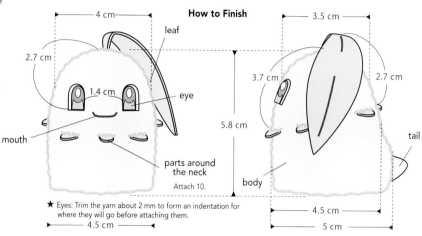

4 cm
2.7 cm
1.4 cm
leaf
eye
mouth
parts around the neck
Attach 10.
4.5 cm

★ Eyes: Trim the yarn about 2 mm to form an indentation for where they will go before attaching them.

3.5 cm
3.7 cm
2.7 cm
5.8 cm
body
tail
4.5 cm
5 cm

Parts

How to Wrap the Yarn

Body　single-strand wrap

① pale yellow green 120
5.5
② pale yellow green 120

left eye

highlight for the eye
pupil
iris
white of the eye

*Make the right eye symmetrical to the left.
*See p. 44.

mouth
❶ Draw a line with the permanent marker.

❷ Apply glue to entire length and carefully create the shape before the glue dries.
*See p. 45.

leaf

Draw lines using the permanent marker.

❶ To make it sturdier, spread glue over the entire back side of the felt and let it dry.

❷ Spread glue on the part that is inserted into the head, then attach to yarn on head.

❸ Spread glue in the center of the back side, then attach to yarn on left side.

tail
Glue the two parts together.

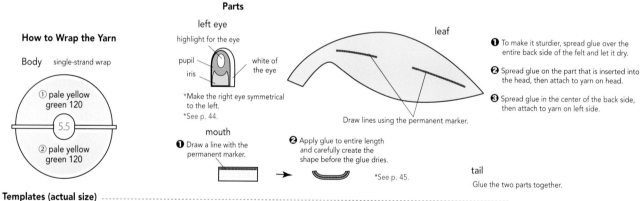

Templates (actual size)

tail
felt (yellow green)
2 pieces

parts around the neck
felt (green) 10 pieces
Insert this part into body.

white of the eye
felt (white) 2 pieces

pupil
fabric (red) 2 pieces

iris
fabric (pink) 2 pieces

highlight for the eye
fabric (white) 2 pieces

leaf
felt (green)
1 piece
Insert this part into head.

mouth
felt (yellow green)
1 piece

Template for Mouth (actual size)

★ p. 73 Minccino

How to Wrap the Yarn

Head and Body　double-strand wrap

① gray 75
3.5
② gray 75

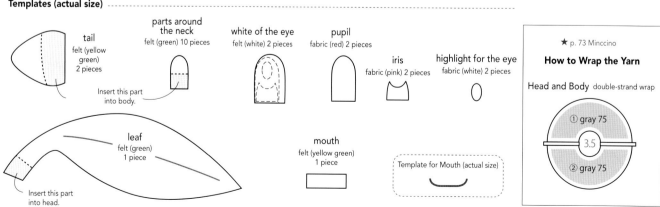

29 Shaymin

Difficulty
p. 27

SUPPLIES (Numbers in parentheses are Hamanaka yarn color codes.)

Yarn: Four Ply ⬤ chartreuse (371), ⬤ white (301)
Piccolo (nose) ⬤ black (20)
Felt: pink (8 x 4 cm), green (7 x 4 cm), yellow and white (small piece of each)
Fabric: cotton broadcloth in white (small piece)

Tools
Pompom maker (5.5 cm), 4 binder clips, scissors, handicraft glue, permanent marker (black superfine point), toothpick

How to Make *See pp. 40–45.
1. Make a two-colored pompom.
2. Trim the bottom.
3. Use the templates to make the different parts.
4. Attach the parts.

Tips
◎ Trimming is critical when creating Shaymin's body. Double-check the measurements.

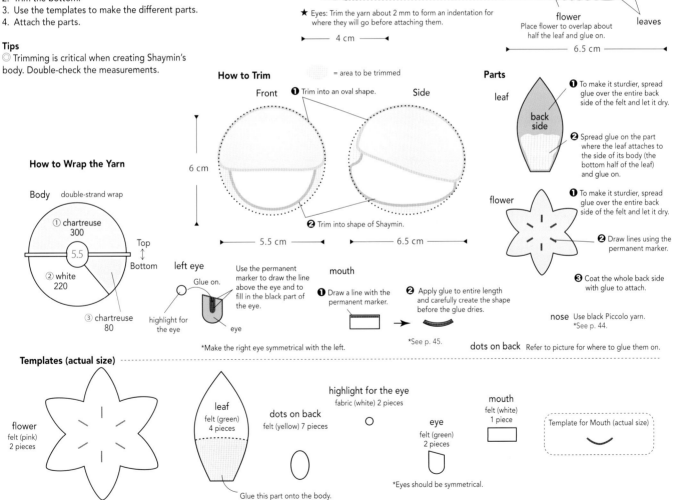

How to Finish

6 cm

dots on back

body

2 cm

4.5 cm

eye

nose

mouth

flower
Place flower to overlap about half the leaf and glue on.

leaves

6.5 cm

1 cm

4 cm

★ Eyes: Trim the yarn about 2 mm to form an indentation for where they will go before attaching them.

How to Trim

▨ = area to be trimmed

Front

❶ Trim into an oval shape.

Side

6 cm

❷ Trim into shape of Shaymin.

5.5 cm

6.5 cm

Parts

leaf

back side

❶ To make it sturdier, spread glue over the entire back side of the felt and let it dry.

❷ Spread glue on the part where the leaf attaches to the side of its body (the bottom half of the leaf) and glue on.

flower

❶ To make it sturdier, spread glue over the entire back side of the felt and let it dry.

❷ Draw lines using the permanent marker.

❸ Coat the whole back side with glue to attach.

How to Wrap the Yarn

Body double-strand wrap

① chartreuse 300

5.5

Top ↑ Bottom

② white 220

③ chartreuse 80

left eye

Glue on.

highlight for the eye

eye

Use the permanent marker to draw the line above the eye and to fill in the black part of the eye.

*Make the right eye symmetrical with the left.

mouth

❶ Draw a line with the permanent marker.

❷ Apply glue to entire length and carefully create the shape before the glue dries.

*See p. 45.

nose Use black Piccolo yarn.
*See p. 44.

dots on back Refer to picture for where to glue them on.

Templates (actual size)

flower
felt (pink)
2 pieces

leaf
felt (green)
4 pieces

Glue this part onto the body.

dots on back
felt (yellow) 7 pieces

highlight for the eye
fabric (white) 2 pieces

eye
felt (green)
2 pieces

*Eyes should be symmetrical.

mouth
felt (white)
1 piece

Template for Mouth (actual size)

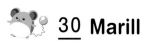

30 Marill

Difficulty ▰▰▰▰▱▱▱▱▱▱
p. 29

SUPPLIES (Numbers in parentheses are Hamanaka yarn color codes.)

Yarn: Piccolo ● blue (23), ○ white (1)
　　　Tino (nose) ● black (15)
Felt: blue (6 x 6 cm) and black (small piece)
Fabric: cotton broadcloth in dark pink and white
(small piece of each)
Thread: white (small amount)

Tools
Pompom maker (3.5 cm, 5.5 cm), 4 binder clips,
scissors, handicraft glue, permanent marker
(black superfine point), toothpick

How to Make *See pp. 40–45.
1. Make a patterned pompom.
2. Trim the body.
3. Make a small pompom.
4. Use the templates to make the different parts.
5. Attach the parts.

Tips
◎ Trim Marill's body so that the bottom is a
little fuller than the top. It should not be a
perfect circle.

How to Wrap the Yarn

Body　double-strand wrap

④ blue 50
③ blue 20　② white 80　① blue 20
5.5
Front ↕ Back
⑤ blue 170

Tail　double-strand wrap
blue 30
3.5

How to Finish

ear　1.9 cm
1.5 cm
eye
nose
mouth
5.8 cm
5.2 cm

body
tail
5.2 cm

★ Eyes: Trim the yarn about 2 mm to form an indentation for where they will go before attaching them.

Parts

eye
highlight for the eye
pupil
Glue on.
*See p. 44.

left eye
❶ Glue two pieces together.　❷ Glue on inner ear.
inner ear
outer ear
*Make the right ear symmetrical to the left.

tail
❶ Make small pompom and shape.
*See pp. 56 and 57 (small pompom instructions).
2 cm
2 cm
form ball
❷ Glue the 2 tail pieces together.
❸ Put glue on tip of tail, insert into small pompom and attach.

mouth
❶ Draw a line with the permanent marker.
❷ Apply glue to entire length and carefully create the shape before the glue dries.
*See p. 45.

nose
Use black Piccolo yarn. *See p. 44.

Templates (actual size)

outer ear
felt (blue)
4 pieces
edge that faces center of the head
Insert this part into the head.

inner ear
fabric (dark pink)
2 pieces

highlight for the eye
fabric (white) 2 pieces

pupil
fabric (black)
2 pieces

tail
felt (black) 2 pieces
body side
tip of the tail side

Template for Mouth (actual size)

mouth
felt (blue) 1 piece

31 Victini

Difficulty ▬▬▬▬▬
p. 31

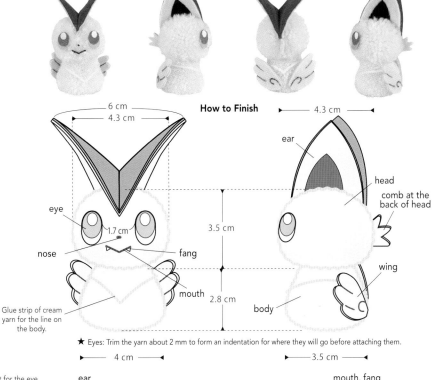

SUPPLIES (Numbers in parentheses are Hamanaka yarn color codes.)

Yarn: Piccolo ○ cream (41)
Tino (nose) ● black (15)
Felt: cream (15 x 7 cm), red (9 x 7 cm) and light blue (small piece of each)
Fabric: cotton broadcloth in black, blue and white (small piece of each)
Thread: white (small amount)

Tools

Pompom maker (3.5 cm), 4 binder clips, scissors, handicraft glue, wool needle, permanent marker (black superfine point), toothpick, tweezers, sewing needle

How to Make *See pp. 40–45.

1. Make solid-color pompoms for the head and body.
2. Attach the two and trim the bottom.
3. Use the templates to make the different parts.
4. Attach the parts.

How to Finish

6 cm
4.3 cm
4.3 cm

ear
head
comb at the back of head

eye
1.7 cm
3.5 cm

nose
fang
wing

mouth
body

3.5 cm
2.8 cm

Glue strip of cream yarn for the line on the body.

★ Eyes: Trim the yarn about 2 mm to form an indentation for where they will go before attaching them.

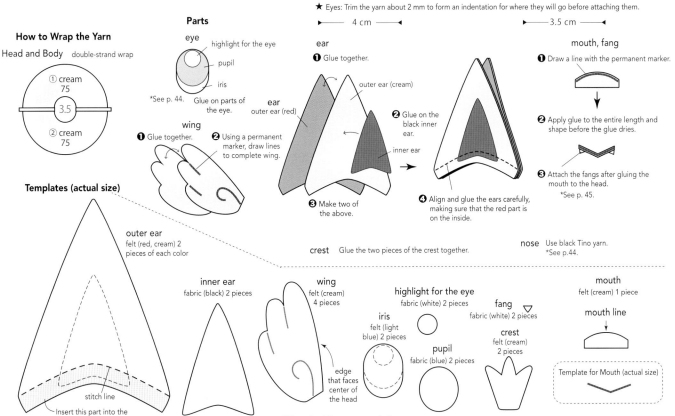

How to Wrap the Yarn

Head and Body double-strand wrap

① cream 75
3.5
② cream 75

Parts

eye
highlight for the eye
pupil
iris
*See p. 44. Glue on parts of the eye.

wing
❶ Glue together.
❷ Using a permanent marker, draw lines to complete wing.

Templates (actual size)

outer ear
felt (red, cream) 2 pieces of each color

stitch line
Insert this part into the head.

ear
❶ Glue together.

outer ear (cream)

ear
outer ear (red)

❷ Glue on the black inner ear.

inner ear

❸ Make two of the above.

❹ Align and glue the ears carefully, making sure that the red part is on the inside.

mouth, fang
❶ Draw a line with the permanent marker.

❷ Apply glue to the entire length and shape before the glue dries.

❸ Attach the fangs after gluing the mouth to the head.
*See p. 45.

crest Glue the two pieces of the crest together.

nose Use black Tino yarn.
*See p.44.

inner ear
fabric (black) 2 pieces

wing
felt (cream) 4 pieces

edge that faces center of the head

highlight for the eye
fabric (white) 2 pieces

iris
felt (light blue) 2 pieces

pupil
fabric (blue) 2 pieces

fang
fabric (white) 2 pieces

crest
felt (cream) 2 pieces

mouth
felt (cream) 1 piece

mouth line

Template for Mouth (actual size)

*Wings should be cut symmetrically.

32 Raichu

Difficulty ▭▭▭▭▭▭
p. 33

SUPPLIES (Numbers in parentheses are Hamanaka yarn color codes.)

Yarn: Piccolo ◯ golden yellow (25), ◯ white (1)
Wanpaku Denis ◯ gray beige (58)
Piccolo (nose) ● black (20)
Felt: yellow (8 x 6 cm), gray beige (7 x 5 cm),
golden yellow and black (small piece of each)
Fabric: cotton broadcloth in white (small piece)
String (narrow): dark-brown cotton (6 cm long)

Tools
Pompom maker (3.5 cm), 4 binder clips, scissors, handicraft glue, wool needle, permanent marker (black superfine point), toothpick

How to Make *See pp. 40–45.
1. Make a solid-color pompom for the head.
2. Make a patterned pompom for the body.
3. Attach the two and trim the bottom.
4. Use the templates to make the different parts.
5. Attach the parts.

Tips
◎ The ears require some detailed work, so be careful and work slowly.

How to Finish

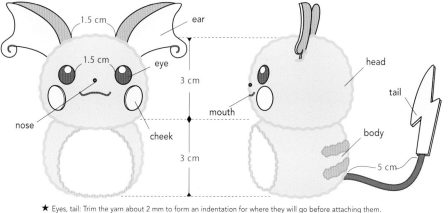

— 4.3 cm —

1.5 cm

ear

1.5 cm

eye

3 cm

nose

mouth

cheek

head

tail

body

3 cm

— 4.3 cm —

— 4 cm —

— 4 cm —

5 cm

★ Eyes, tail: Trim the yarn about 2 mm to form an indentation for where they will go before attaching them.

Parts

left eye

highlight for the eye
pupil
Glue together.

*Make right eye symmetrical to the left.
*See p. 44.

tail
❶ Glue the tip of tail to the cotton string.

dark-brown string

tip of tail

❷ Glue the second tip over the first, with the end of the string in between.

mouth
❶ Draw a line using the permanent marker.

❷ Apply glue to entire length and carefully create the shape before the glue dries.

*See p. 45.

nose Use black Piccolo yarn.
*See p. 44.

left ear

left outer ear

left inner ear

left ear (front side)

❶ Glue the parts (inner and outer) to the front side of the left ear.

❷ Draw the curve with a permanent black marker.

*Make the right ear symmetrical to the left.

How to Wrap the Yarn

Body double-strand wrap

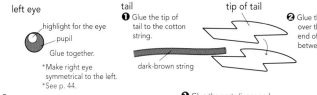

Head double-strand wrap

① golden yellow 75

3.5

② golden yellow 75

③ golden yellow 7
④ gray beige 5
⑤ golden yellow 10
② gray beige 5
① golden yellow 10
⑥ golden yellow 35
Back ↕ Front
⑦ white 40
⑧ golden yellow 35

Templates (actual size)

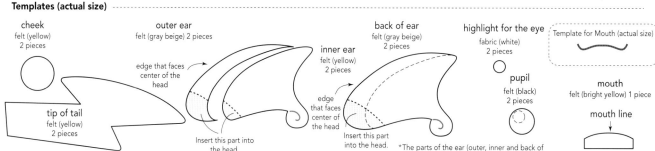

cheek
felt (yellow)
2 pieces

tip of tail
felt (yellow)
2 pieces

outer ear
felt (gray beige) 2 pieces

edge that faces center of the head

Insert this part into the head.

inner ear
felt (yellow)
2 pieces

edge that faces center of the head

Insert this part into the head.

back of ear
felt (gray beige)
2 pieces

*The parts of the ear (outer, inner and back of ear) should be cut symmetrically.

highlight for the eye
fabric (white)
2 pieces

pupil
felt (black)
2 pieces

Template for Mouth (actual size)

mouth
felt (bright yellow) 1 piece

mouth line

33 Pichu

Difficulty ▭▭▭▭▭
p. 33

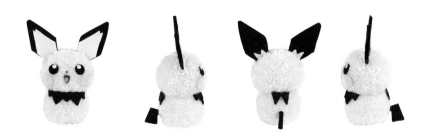

SUPPLIES (Numbers in parentheses are Hamanaka yarn color codes.)

Yarn: Four Ply pale yellow (323)
 Tino (nose) ⬤ black (15)
Felt: black (11 x 8 cm), pink and red (small piece of each)
Fabric: cotton broadcloth in pale yellow, white and pink (small piece of each)

Tools
Pompom maker (3.5 cm), 4 binder clips, scissors, handicraft glue, wool needle, permanent marker (black superfine point), toothpick

How to Make *See pp. 40–45.
1. Make solid-color pompoms for the head and body.
2. Attach the two and trim the bottom.
3. Use the templates to make the different parts.
4. Attach the parts.

Tips
◎ The petite mouth will have a tongue glued to it. If done with care, Pichu will look very cute.

How to Finish

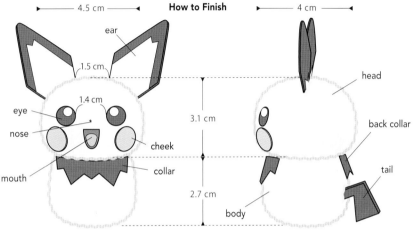

★ Eyes, mouth: Trim the yarn about 2 mm to form an indentation for where they will go before attaching them.

How to Wrap the Yarn

Head and Body double-strand wrap

① pale yellow 110
3.5
② pale yellow 110

Parts

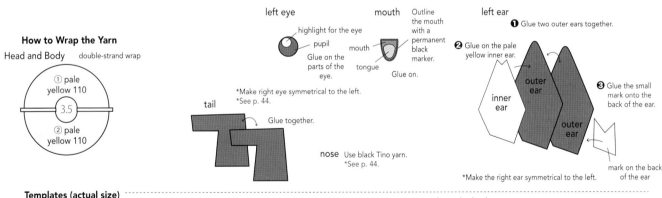

left eye

highlight for the eye
pupil
Glue on the parts of the eye.

*Make right eye symmetrical to the left.
*See p. 44.

tail Glue together.

mouth

Outline the mouth with a permanent black marker.
mouth
tongue
Glue on.

nose Use black Tino yarn.
*See p. 44.

left ear

❶ Glue two outer ears together.

❷ Glue on the pale yellow inner ear.

inner ear outer ear outer ear

❸ Glue the small mark onto the back of the ear.

mark on the back of the ear

*Make the right ear symmetrical to the left.

Templates (actual size)

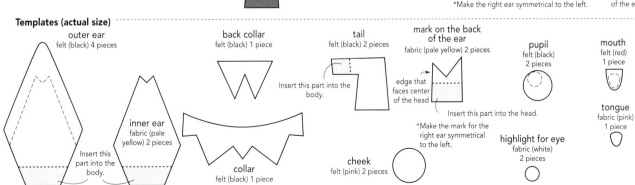

outer ear
felt (black) 4 pieces

inner ear
fabric (pale yellow) 2 pieces

Insert this part into the body.

back collar
felt (black) 1 piece

collar
felt (black) 1 piece

tail
felt (black) 2 pieces

Insert this part into the body.

mark on the back of the ear
fabric (pale yellow) 2 pieces

edge that faces center of the head

Insert this part into the head.

*Make the mark for the right ear symmetrical to the left.

cheek
felt (pink) 2 pieces

pupil
felt (black) 2 pieces

highlight for eye
fabric (white) 2 pieces

mouth
felt (red) 1 piece

tongue
fabric (pink) 1 piece

POMPOM POKÉMON by Sachiko Susa

Book Design: Fumie Terayama
Photography: Yukari Shirai (Cover), Yuki Morimura (Process)
Stylist: Tomomi Enai
Production Assistance: Katsue Ogura, Natsuki Susa
Editorial Assistance: Yoshiko Ando, Atsuko Takasawa
Editor: Chiho Yamanaka

VIZ Media Edition
Translation: JN Productions
Design: Izumi Evers
Editor: Nancy Thistlethwaite

Printed in Korea

Published by VIZ Media, LLC
P.O. Box 77010
San Francisco, CA 94107

10 9 8 7 6 5 4 3 2 1
First printing, September 2018

Materials Used in This Book
Yarn: Hamanaka
http://www.hamanaka.co.jp
Notions: Clover
http://www.clover.co.jp

Profile
Sachiko Susa

After working in planning and design at a plush toy company, Susa began a career as a handicraft artist. She creates needle-felted mascots, knickknacks and stuffed toys, and she publishes her creations in magazines and books. She produces needle-felt kits from handicraft manufacturers and also teaches needle-felting classes. She has written books on pompom and needle-felted characters.
http://susa3203.com/

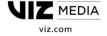
VIZ MEDIA
viz.com